BLAKE'S
"AMERICA: A PROPHECY"
AND
"EUROPE: A PROPHECY"

Facsimile Reproductions of Two Illuminated Books
With 35 Plates in Full Color

William Blake

DOVER PUBLICATIONS, INC.
NEW YORK

PUBLISHER'S NOTE

William Blake (1757–1827), one of the world's great visionaries, transmuted not only the burning events and issues of his day (the American War of Independence; the French Revolution; colonialism, slavery and the expansion of empire; the Industrial Revolution) but even details of his intimate existence into an elaborate personal mythology in which titanic forces of revolt struggle for freedom against the guardians of tradition.

A printer by profession, a trained engraver and illustrator, and a poet of striking power, Blake enshrined much of his thought and emotion in a series of unique illuminated books. Both his calligraphed text and his images were engraved on copperplates in an unusual technique (the lines to be printed being higher than the metal surface rather than incised within it), and then printed in colored inks.

The time-consuming coloring in of the images—either with watercolor applied by hand to the printed sheets or via opaque pigments spread onto the plates themselves—was apparently undertaken by Blake only when there was an immediate prospect of selling such a copy; of the sixteen known copies of the book *America: A Prophecy* only four are colored, while only eight of the twelve known copies of *Europe: A Prophecy* are colored. Obviously, no two copies are exactly alike.*

America, dated 1793, was probably not printed before 1794, the year of the first appearance of *Europe. America,* relatively easy to understand once the reader becomes somewhat familiar with the poet's basic mythopoeic approach, is fairly directly based on persons and events connected with the American Revolution. *Europe,* which provides a sort of history of Occidental morality up to Blake's time, is much more involved with characters from the poet's extensive pantheon and cannot readily be interpreted without knowledge of other poems in which they are introduced. In both *America* and *Europe* the illustrations are sometimes based closely on the text of the plates on which they appear, but are often more loosely connected and open to varying interpretations.

The present volume not only provides a typeset transcription (beginning on page 42) of Blake's calligraphed texts of the two poems, retaining his spelling and punctuation (except for the deletion of colons that interrupt the syntax of a clause), but also offers very brief plate-by-plate analytical summaries of both text and illustrations (for *America,* on page 3; for *Europe,* on page 23). These analyses are of course based on those of such great Blake scholars as Geoffrey Keynes, David V. Erdman and S. Foster Damon; Damon's *Blake Dictionary* (Brown University Press, 1965) is especially recommended to those who wish more information on the poems *America* and *Europe,* their place in Blake's output and the mythology they embody.

*Known copies of Blake's books are often referred to by the letters assigned to them in a standard census of such extant copies. The present volume reproduces the complete copy M of *America* (printed on paper made in 1799), whereas the complete *Europe* reproduced here includes colored plates from copies B and G of that book and the black-and-white plate from copy K (all these copies are privately owned). Note that *Europe* contains two plates numbered 9—referred to in the present edition as 9(a) and 9(b)—and has no plate numbered 11.

Copyright © 1983 by Dover Publications, Inc.
All rights reserved under Pan American and International Copyright Conventions.

Published in Canada by General Publishing Company, Ltd., 30 Lesmill Road, Don Mills, Toronto, Ontario.

This Dover edition, first published in 1983, consists of: (1) the 18 plates of *America; A Prophecy* (originally published by Blake, 1793/4); (2) the 18 plates of *Europe: A Prophecy* (originally published by Blake, 1794); (3) a new Publisher's Note and brief explanations of text and images, prepared specially for the present edition; and (4) a typeset transcription of the two poetic texts.

Manufactured in the United States of America
Dover Publications, Inc., 31 East 2nd Street, Mineola, N.Y. 11501

Library of Congress Cataloging in Publication Data

Blake, William, 1757–1827.
 Blake's "America, a prophecy"; and, "Europe, a prophecy."

 Reprint (1st work). Originally published: Lambeth : W. Blake, 1793.
 Reprint (2nd work). Originally published: 1st ed. Lambeth : W. Blake, 1794.
 1. Blake, William, 1757–1827. America, a prophecy—Illustrations. 2. United States—History—Revolution, 1775–1783—Poetry. 3. Blake, William, 1757–1827. Europe—Illustrations. I. Blake, William, 1757–1827. America, a prophecy. 1983. II. Blake, William, 1757–1827. Europe. 1983. III. Title. IV. Title: America, a prophecy.
NE642.B5A4 1983 769.92′4 83-7186
ISBN 0-486-24548-9

"AMERICA: A PROPHECY"

SUMMARY OF POEM (for full printed text, see page 42)

(PLATE 1:) Orc, the spirit of revolution, who has been chained by his parent gods Los and Enitharmon, is fed by the Shadowy Female (daughter of Urthona), who represents the material world. One day, he declares his love for her. (PLATE 2:) He breaks his bonds, and their ensuing intercourse is prophetic of uprisings against colonialism in the Western Hemisphere. (PLATE 3:) The American patriots convene and realize their servitude to Albion (England). The Prince of Albion (George III) glowers. (PLATES 4 & 5:) Orc appears on the Atlantic, frightening Albion. (PLATE 6:) A voice proclaims liberty and the end of empire. (PLATE 7:) Albion's Angel recognizes Orc. (PLATE 8:) Orc announces that he will destroy the harsh, repressive laws of Urizen (the personification of cold reason; reminiscent of the Old Testament Jehovah) and achieve complete human brotherhood. (PLATE 9:) Albion calls for war and orders his Thirteen Angels (the American colonies) to rally to his aid. (PLATE 10:) The colonies refuse. (PLATE 11:) Boston's Angel renounces loyalty to England. (PLATE 12:) Revolution breaks out in the American colonies. (PLATE 13:) English soldiers are defeated in America. (PLATE 14:) Albion's Angel calls down plagues on America, but they recoil upon England. (PLATE 15:) Diseases ravage England. (PLATE 16:) Even the Heavens melt and Urizen becomes leprous; but he wraps the flaming earth in snow and mist for twelve years—until the French Revolution.

BRIEF IDENTIFICATION OF ILLUSTRATIONS

FRONTISPIECE: A titanic gloomy figure. TITLE PAGE: War cloud; woman trying to revive dead man. PLATE 1: Orc, chained; his parents, repentant; at the bottom left, Orc's imagination (or else, the Spirit of Man) in confinement. PLATE 2: Orc (or Spirit of Man) breaks forth. PLATE 3: A fiery war trumpet; a soaring figure with broken chains. PLATE 4: A war dragon pursues Urizen. PLATE 5: A scene of the Last Judgment (?). PLATE 6: Man regenerated. PLATE 7: A pastoral scene of innocence. PLATE 8: Urizen reigning. PLATE 9: Man in a grain field. PLATE 10: Orc in the blaze of revolution. PLATE 11: Nude figures (of innocence) controlling forces of nature. PLATE 12: An old man entering the tomb. PLATE 13: Oothoon (thwarted love) attacked by an eagle; a drowned man as food for fishes. PLATE 14: Young man receiving sinful instruction. PLATE 15: The "fires of Orc, . . . Leaving the females naked and glowing with the lusts of youth." PLATE 16: Nature prostrate beside a precipice. (The pessimistic last five plates have been interpreted as the moral failure of the revolution.)

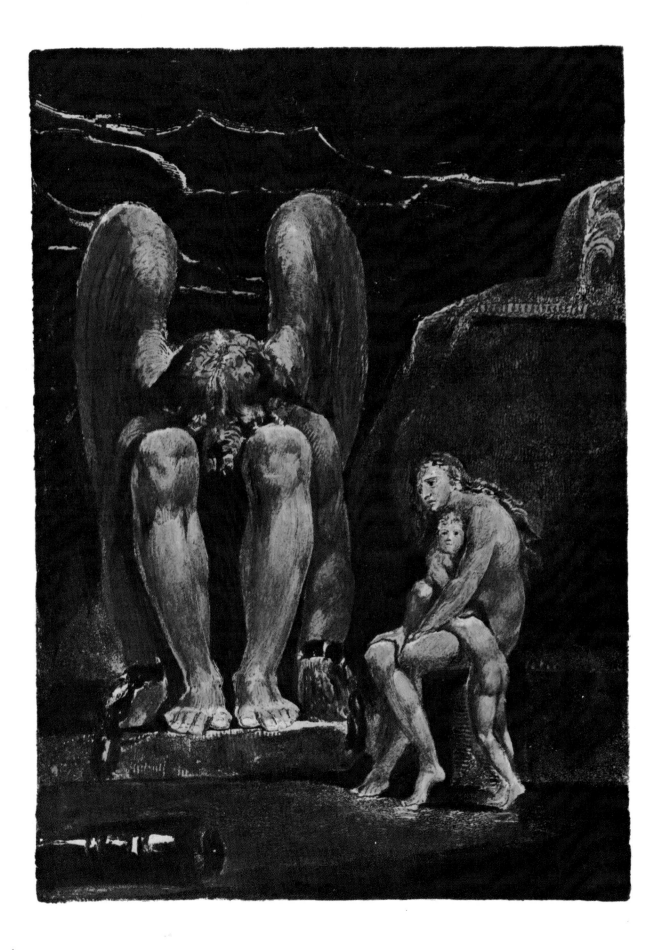

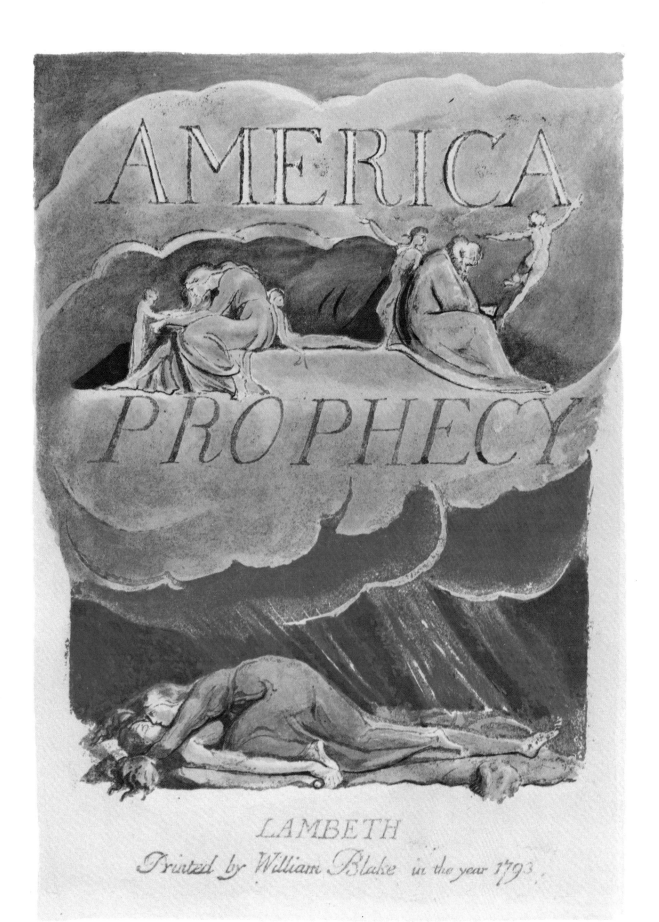

AMERICA

PROPHECY

LAMBETH

Printed by William Blake in the year 1793.

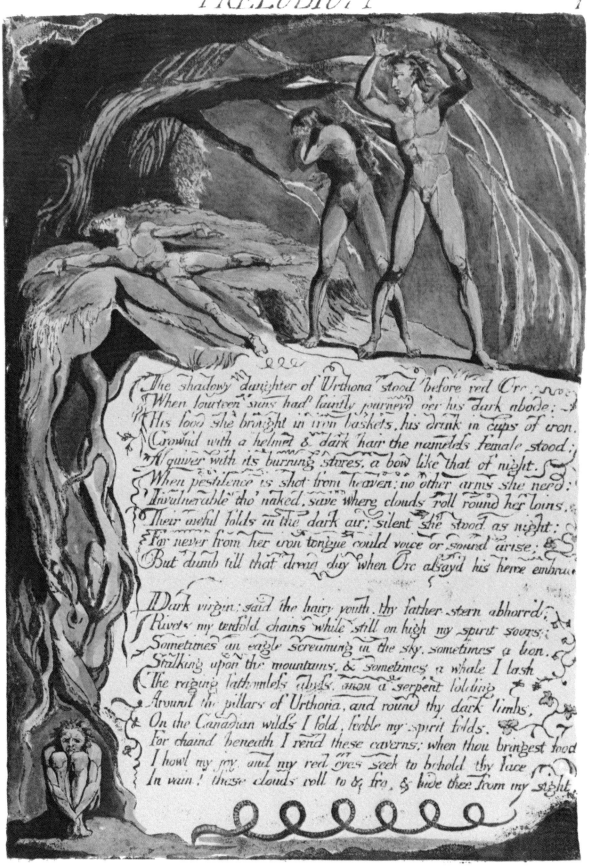

The shadowy daughter of Urthona stood before red Orc.
When fourteen suns had faintly journeyd oer his dark abode;
His food she brought in iron baskets, his drink in cups of iron;
Crownd with a helmet & dark hair the nameless female stood;
A quiver with its burning stores, a bow like that of night,
When pestilence is shot from heaven; no other arms she need:
Invulnerable tho' naked, save where clouds roll round her loins,
Their awful folds in the dark air; silent she stood as night;
For never from her iron tongue could voice or sound arise;
But dumb till that dread day when Orc assayd his fierce embrace.

Dark virgin; said the hairy youth, thy father stern abhorrd;
Rivets my tenfold chains while still on high my spirit soars;
Sometimes an eagle screaming in the sky, sometimes a lion,
Stalking upon the mountains, & sometimes a whale I lash
The raging fathomless abyss, anon a serpent folding
Around the pillars of Urthona, and round thy dark limbs,
On the Canadian wilds I fold, feeble my spirit folds.
For chaind beneath I rend these caverns; when thou bringest food
I howl my joy; and my red eyes seek to behold thy face
In vain! these clouds roll to & fro, & hide thee from my sight.

Silent as despairing love. and strong as jealousy.
The hairy shoulders rend the links. free are the wrists of fire;
Round the terrific loins he siez'd the panting struggling womb;
It joyd: she put aside her clouds & smiled her first-born smile.
As when a black cloud shews its lightnings to the silent deep.

Soon as she saw the terrible boy then burst the virgin cry.

I know thee, I have found thee, & I will not let thee go;
Thou art the image of God who dwells in darkness of Africa
And thou art fall'n to give me life in regions of dark death.
On my American plains I feel the struggling afflictions
Endur'd by roots that writhe their arms into the nether deep:
I see a serpent in Canada, who courts me to his love;
In Mexico an Eagle, and a Lion in Peru;
I see a Whale in the South-sea, drinking my soul away.
O what limb rending pains I feel. thy fire & my frost
Mingle in howling pains, in furrows by thy lightnings rent;
This is eternal death: and this the torment long foretold.

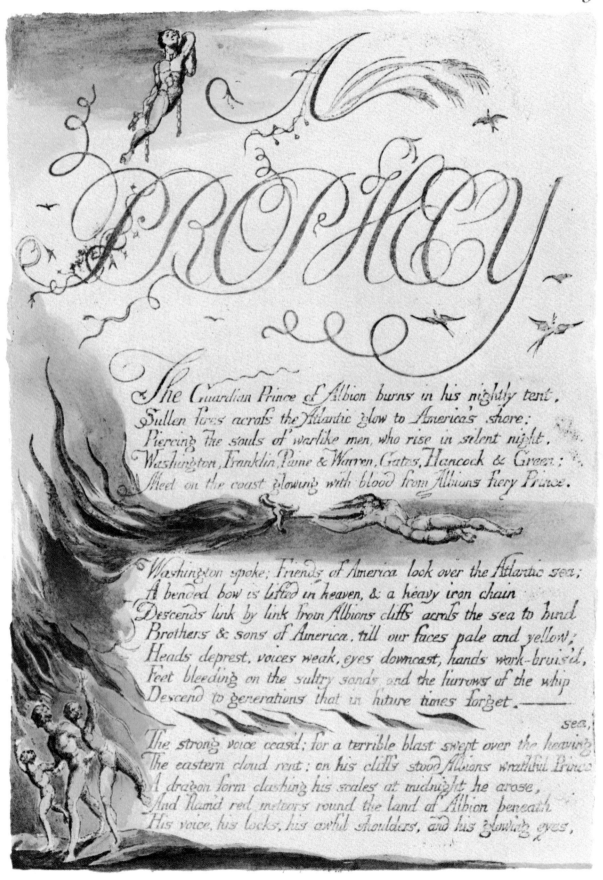

A PROPHECY

The Guardian Prince of Albion burns in his nightly tent,
Sullen fires across the Atlantic glow to America's shore:
Piercing the souls of warlike men, who rise in silent night,
Washington, Franklin, Paine & Warren, Gates, Hancock & Green;
Meet on the coast glowing with blood from Albions fiery Prince.

Washington spoke; Friends of America look over the Atlantic sea;
A bended bow is lifted in heaven, & a heavy iron chain
Descends link by link from Albions cliffs across the sea to bind
Brothers & sons of America, till our faces pale and yellow;
Heads deprest, voices weak, eyes downcast, hands work-bruis'd,
Feet bleeding on the sultry sands, and the furrows of the whip
Descend to generations that in future times forget.——

 sea,
The strong voice ceas'd; for a terrible blast swept over the heaving
The eastern cloud rent; on his cliffs stood Albions wrathful Prince
A dragon form clashing his scales at midnight he arose,
And flam'd red meteors round the land of Albion beneath
His voice, his locks, his awful shoulders, and his glowing eyes,

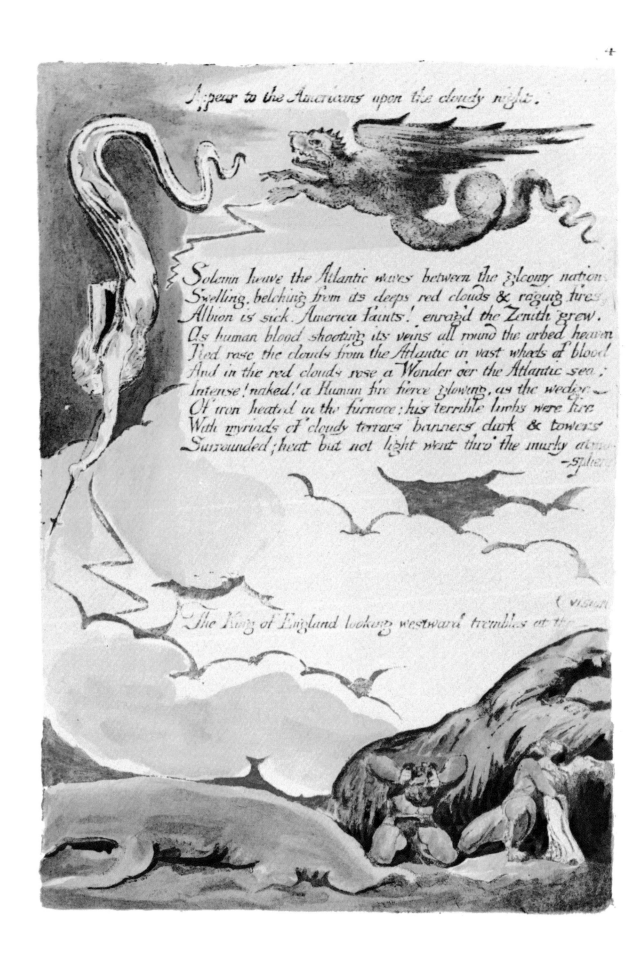

Appear to the Americans upon the cloudy night.

Solemn heave the Atlantic waves between the gloomy nations
Swelling, belching from its deeps red clouds & raging fires
Albion is sick. America faints! enrag'd the Zenith grew.
As human blood shooting its veins all round the orbed heaven
Red rose the clouds from the Atlantic in vast wheels of blood
And in the red clouds rose a Wonder o'er the Atlantic sea;
Intense! naked! a Human fire fierce glowing, as the wedge
Of iron heated in the furnace; his terrible limbs were fire
With myriads of cloudy terrors banners dark & towers
Surrounded; heat but not light went thro' the murky atmo-
 —sphere

The King of England looking westward trembles at the

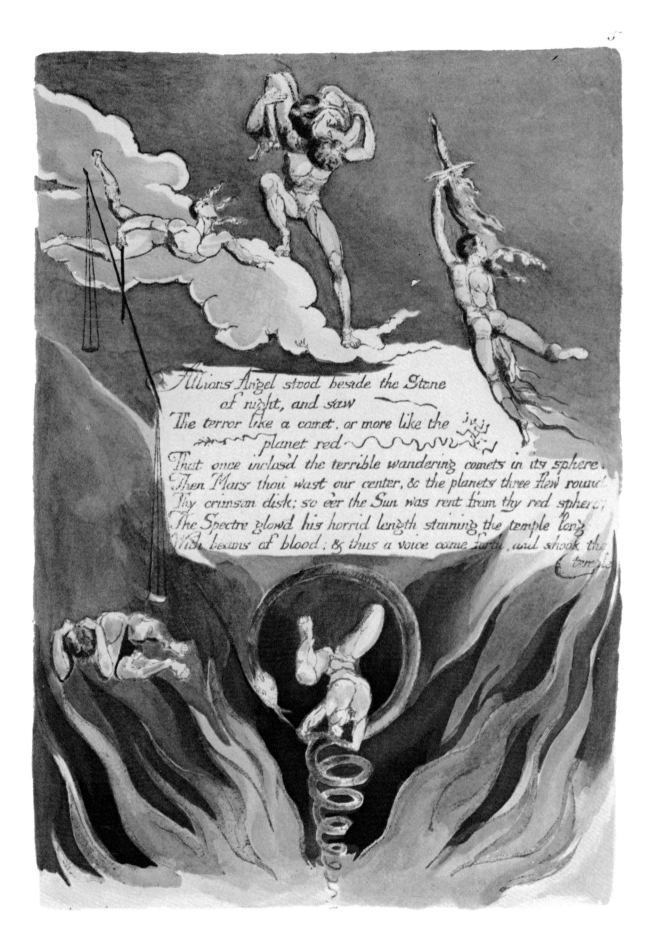

Albions Angel stood beside the Stone
of night, and saw
The terror like a comet, or more like the
planet red
That once inclos'd the terrible wandering comets in its sphere.
Then Mars thou wast our center, & the planets three flew round
Thy crimson disk; so e'er the Sun was rent from thy red sphere;
The Spectre glow'd his horrid length staining the temple long
With beams of blood; & thus a voice came forth, and shook the temple

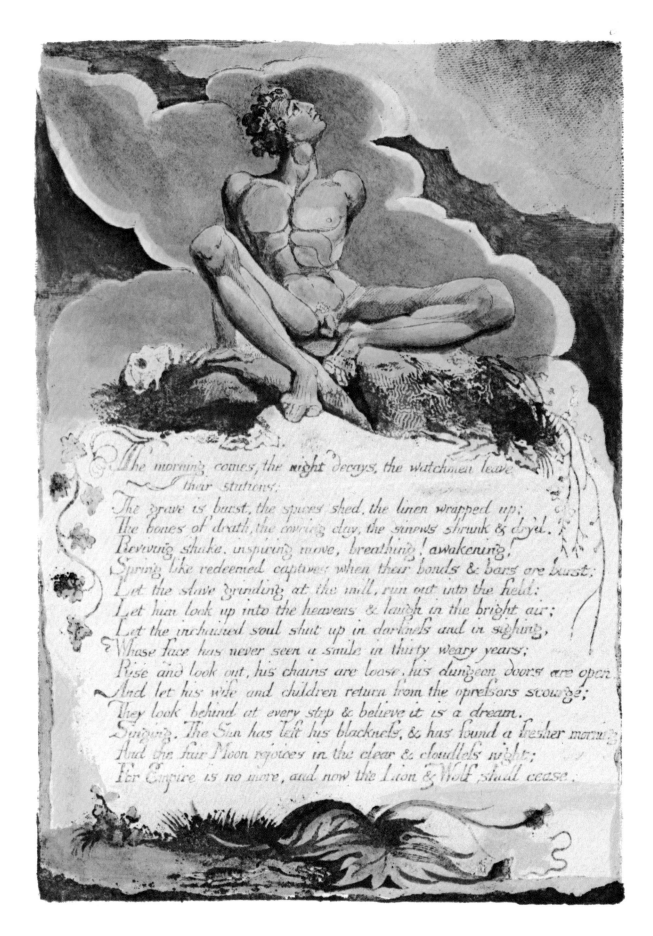

The morning comes, the night decays, the watchmen leave
 their stations;
The grave is burst, the spices shed, the linen wrapped up;
The bones of death, the covering clay, the sinews shrunk & dry'd.
Reviving shake, inspiring move, breathing! awakening!
Spring like redeemed captives when their bonds & bars are burst;
Let the slave grinding at the mill, run out into the field:
Let him look up into the heavens & laugh in the bright air;
Let the inchained soul shut up in darkness and in sighing,
Whose face has never seen a smile in thirty weary years;
Rise and look out, his chains are loose, his dungeon doors are open
And let his wife and children return from the opressors scourge;
They look behind at every step & believe it is a dream.
Singing, The Sun has left his blackness, & has found a fresher morning
And the fair Moon rejoices in the clear & cloudless night;
For Empire is no more, and now the Lion & Wolf shall cease.

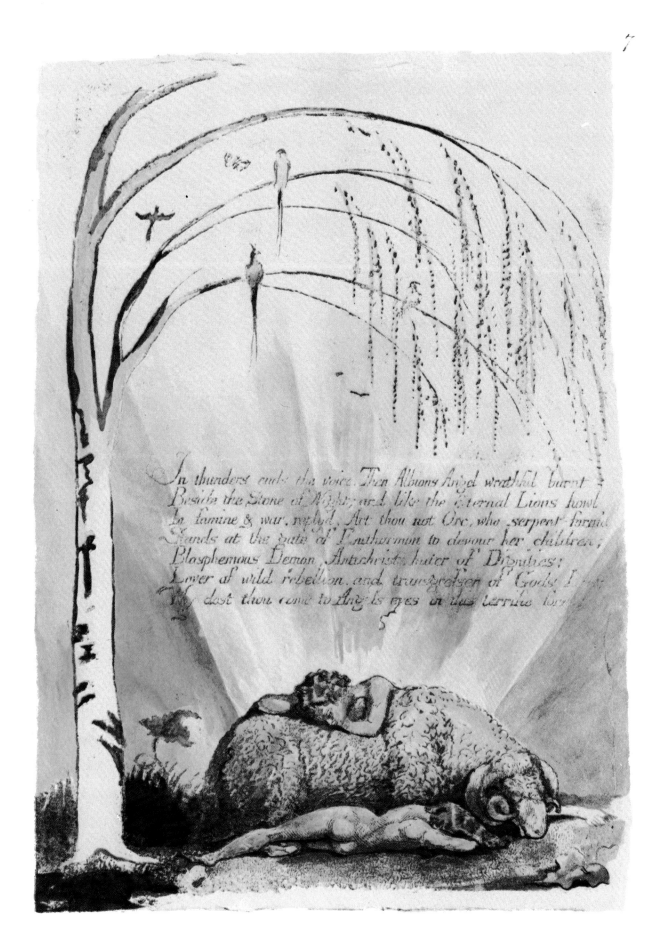

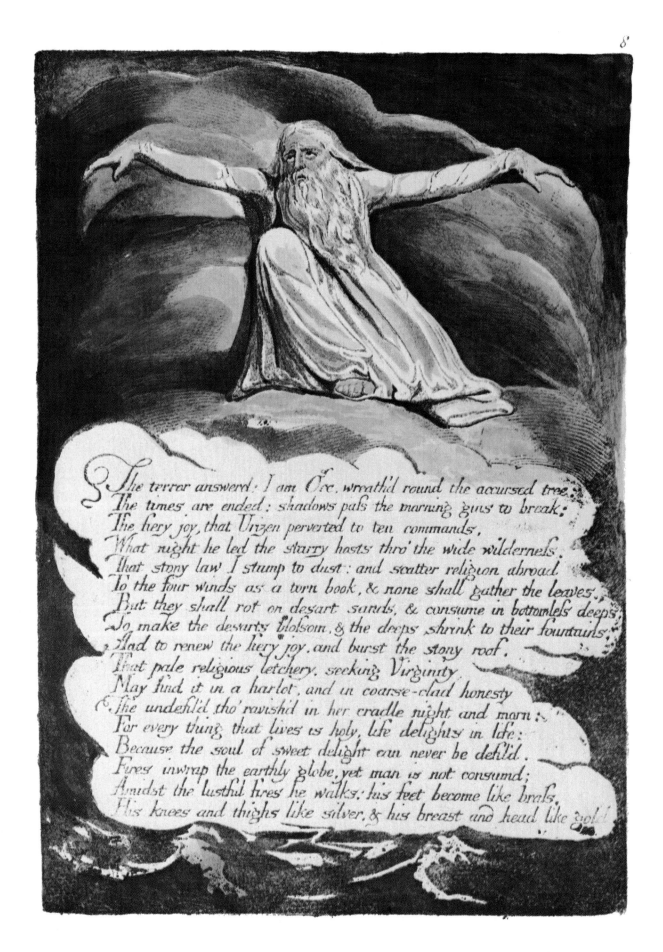

The terror answerd: I am Orc, wreath'd round the accursed tree:
The times are ended; shadows pass the morning gins to break;
The fiery joy, that Urizen perverted to ten commands,
What night he led the starry hosts thro' the wide wilderness:
That stony law I stamp to dust: and scatter religion abroad
To the four winds as a torn book, & none shall gather the leaves;
But they shall rot on desart sands, & consume in bottomless deeps;
To make the desarts blossom, & the deeps shrink to their fountains,
And to renew the fiery joy, and burst the stony roof.
That pale religious letchery, seeking Virginity,
May find it in a harlot, and in coarse-clad honesty
The undefil'd tho' ravish'd in her cradle night and morn:
For every thing that lives is holy, life delights in life;
Because the soul of sweet delight can never be defil'd.
Fires inwrap the earthly globe, yet man is not consumd;
Amidst the lustful fires he walks; his feet become like brass,
His knees and thighs like silver, & his breast and head like gold.

Sound! sound! my loud war-trumpets & alarm my Thirteen Angels!
Loud howls the eternal Wolf! the eternal Lion lashes his tail!
America is darkned; and my punishing Demons terrified
Crouch howling before their caverns deep like skins dryd in the wind.
They cannot smite the wheat, nor quench the fatness of the earth.
They cannot smite with sorrows, nor subdue the plow and spade.
They cannot wall the city, nor moat round the castle of princes.
They cannot bring the stubbed oak to overgrow the hills.
For terrible men stand on the shores, & in their robes I see
Children take shelter from the lightnings, there stands Washington
And Paine and Warren with their foreheads reard toward the east
But clouds obscure my aged sight. A vision from afar!
Sound! sound! my loud war-trumpets & alarm my thirteen Angels:
Ah vision from afar! Ah rebel form that rent the ancient
Heavens; Eternal Viper self-renew'd, rolling in clouds
I see thee in thick clouds and darkness on Americas shore.
Writhing in pangs of abhorred birth; red flames the crest rebellious
And eyes of death; the harlot womb oft opened in vain
Heaves in enormous circles, now the times are return'd upon thee,
Devourer of thy parent, now thy unutterable torment renews.
Sound! sound! my loud war-trumpets & alarm my thirteen Angels.
Ah terrible birth! a young one bursting! where is the weeping mouth?
And where the mothers milk? instead those ever-hissing jaws
And parched lips drop with fresh gore; now roll thou in the clouds
Thy mother lays her length outstretch'd upon the shore beneath.
Sound! sound! my loud war-trumpets & alarm my thirteen Angels.
Loud howls the eternal Wolf! the eternal Lion lashes his tail!

Thus wept the Angel voice & as he wept the terrible blasts
Of trumpets, blew a loud alarm across the Atlantic deep.
No trumpets answer; no reply of clarions or of fifes,
Silent the Colonies remain and refuse the loud alarm.

On those vast shady hills between America & Albions shore;
Now barrd out by the Atlantic sea: call'd Atlantean hills:
Because from their bright summits you may pass to the Golden world
An ancient palace, archetype of mighty Emperies.
Rears its immortal pinnacles, built in the forest of God
By Ariston the king of beauty for his stolen bride.

Here on their magic seats the thirteen Angels sat perturb'd
For clouds from the Atlantic hover oer the solemn roof.

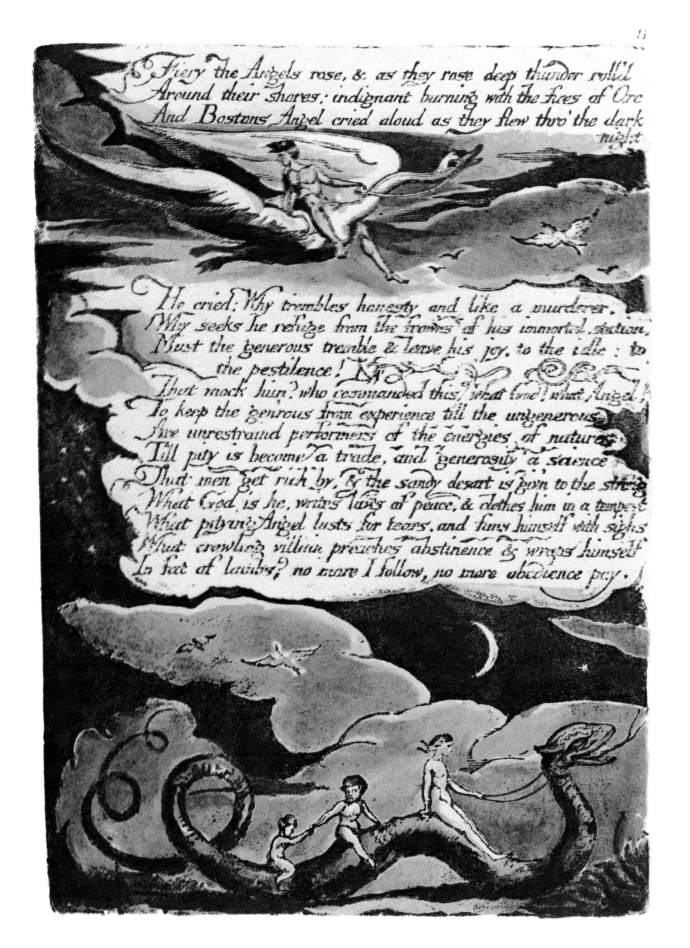

Fiery the Angels rose, & as they rose deep thunder roll'd
Around their shores, indignant burning with the fires of Orc
And Bostons Angel cried aloud as they flew thro' the dark
 night

He cried: Why trembles honesty and like a murderer.
Why seeks he refuge from the frowns of his immortal station,
Must the generous tremble & leave his joy, to the idle : to
 the pestilence!
That mock him? who commanded this? what God? what Angel?
To keep the genrous from experience till the ungenerous
Are unrestraind performers of the energies of nature;
Till pity is become a trade, and generosity a science
That men get rich by, & the sandy desert is given to the strong
What God is he, writes laws of peace, & clothes him in a tempest
What pitying Angel lusts for tears, and fans himself with sighs
What crawling villain preaches abstinence & wraps himself
In fat of lambs? no more I follow, no more obedience pay.

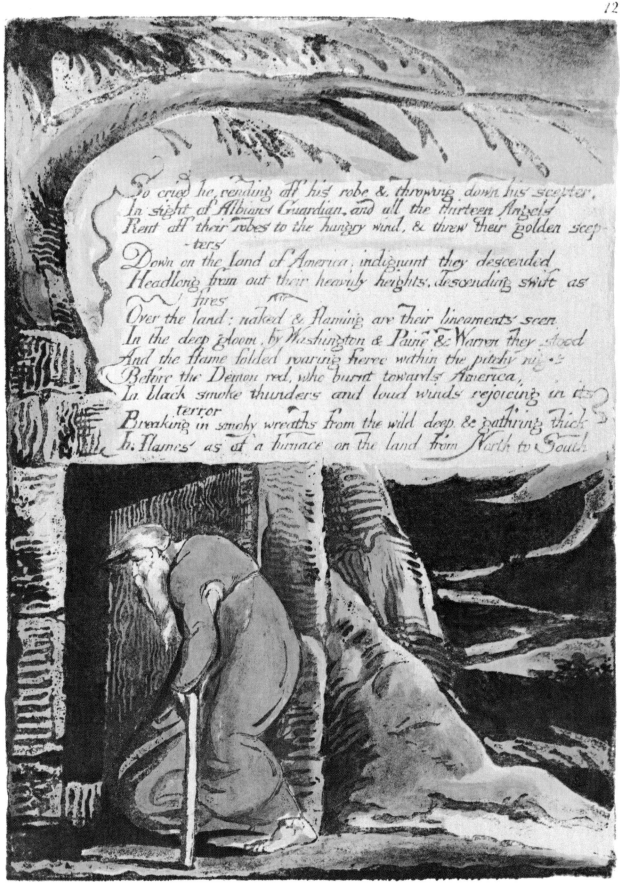

So cried he, rending off his robe & throwing down his scepter,
In sight of Albions Guardian, and all the thirteen Angels
Rent all their robes to the hungry wind, & threw their golden scep-
- ters
Down on the land of America; indignant they descended
Headlong from out their heavenly heights, descending swift as
fires
Over the land; naked & flaming are their lineaments seen
In the deep gloom, by Washington & Paine & Warren they stood
And the flame folded roaring fierce within the pitchy night
Before the Demon red, who burnt towards America,
In black smoke thunders and loud winds rejoicing in its
terror
Breaking in smoky wreaths from the wild deep, & gathering thick
In flames as of a furnace on the land from North to South

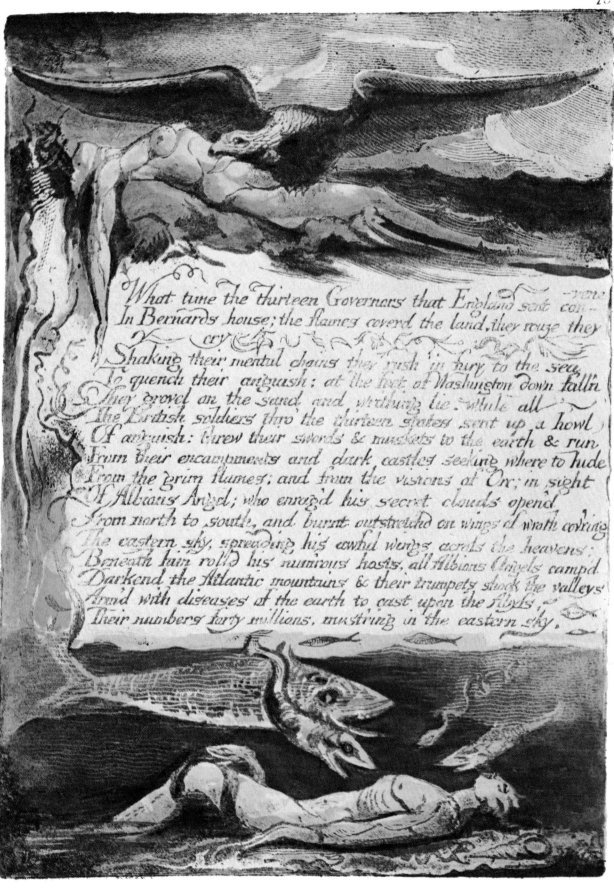

What time the thirteen Governors that England sent con-
In Bernards house; the flames coverd the land, they rouze they
cry
Shaking their mental chains they rush in fury to the sea
To quench their anguish: at the feet of Washington down falln
They grovel on the sand and writhing lie, while all
The British soldiers thro' the thirteen states sent up a howl
Of anguish: threw their swords & muskets to the earth & run
From their encampments and dark castles seeking where to hide
From the grim flames; and from the visions of Orc; in sight
Of Albions Angel; who enrag'd his secret clouds opend
From north to south, and burnt outstretchd on wings of wrath cov'ring
The eastern sky, spreading his awful wings across the heavens;
Beneath him rolld his numrous hosts, all Albions Angels campd.
Darkend the Atlantic mountains & their trumpets shook the valleys
Armd with diseases of the earth to cast upon the Abyss,
Their numbers forty millions, must'ring in the eastern sky.

In the flames stood & viewd the armies drawn out in the sky,
Washington Franklin Paine & Warren Allen Gates & Lee:
And heard the voice of Albions Angel give the thunderous command:
His plagues obedient to his voice flew forth out of their clouds
Falling upon America, as a storm to cut them off
As a blight cuts the tender corn when it begins to appear.
Dark is the heaven above, & cold & hard the earth beneath:
And as a plague wind filld with insects cuts off man & beast;
And as a sea oerwhelms a land in the day of an earthquake:

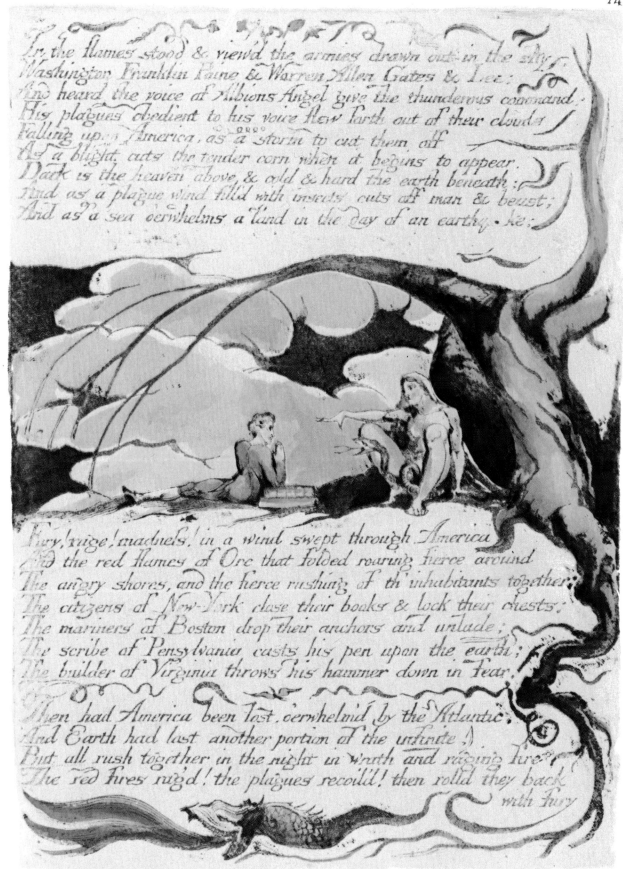

Fury! rage! madness! in a wind swept through America
And the red flames of Orc that folded roaring fierce around
The angry shores, and the fierce rushing of th'inhabitants together:
The citizens of New-York close their books & lock their chests;
The mariners of Boston drop their anchors and unlade;
The scribe of Pensylvania casts his pen upon the earth;
The builder of Virginia throws his hammer down in fear.

Then had America been lost, oerwhelmd by the Atlantic,
And Earth had lost another portion of the infinite,
But all rush together in the night in wrath and raging fire
The red fires rag'd! the plagues recoil'd! then rolld they back
with fury

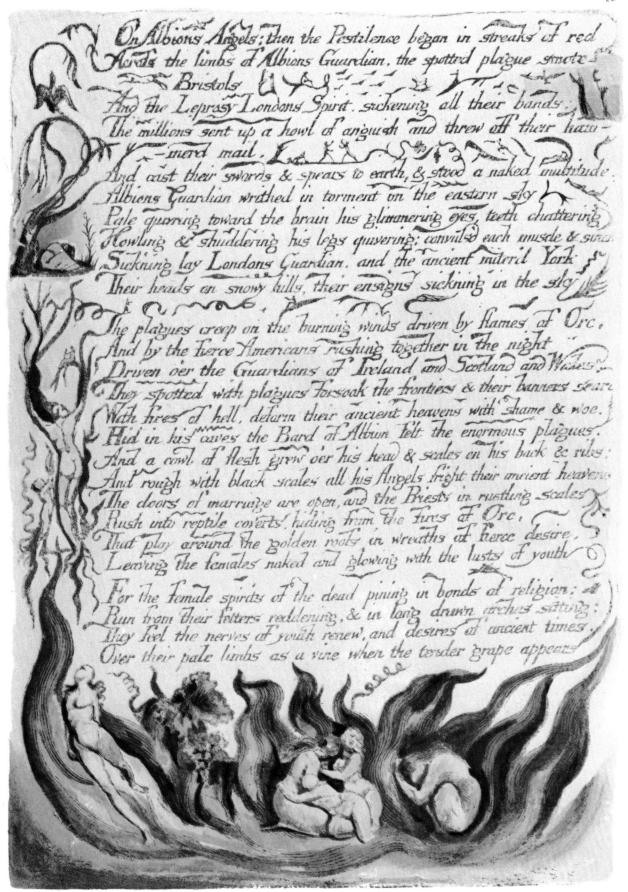

On Albions Angels; then the Pestilence began in streaks of red
Across the limbs of Albions Guardian, the spotted plague smote Bristols

And the Leprosy Londons Spirit, sickening all their bands;
The millions sent up a howl of anguish and threw off their hammer'd mail.

And cast their swords & spears to earth, & stood a naked multitude.
Albions Guardian writhed in torment on the eastern sky
Pale quivring toward the brain his glimmering eyes, teeth chattering
Howling & shuddering his legs quivering; convuls'd each muscle & sinew
Sickning lay Londons Guardian, and the ancient miter'd York
Their heads on snowy hills, their ensigns sickning in the sky

The plagues creep on the burning winds driven by flames of Orc.
And by the fierce Americans rushing together in the night
Driven o'er the Guardians of Ireland and Scotland and Wales,
They spotted with plagues forsook the frontiers & their banners sear'd
With fires of hell, deform their ancient heavens with shame & woe.
Hid in his caves the Bard of Albion felt the enormous plagues.
And a cowl of flesh grew o'er his head & scales on his back & ribs;
And rough with black scales all his Angels fright their ancient heavens
The doors of marriage are open, and the Priests in rustling scales
Rush into reptile coverts, hiding from the fires of Orc,
That play around the golden roofs in wreaths of fierce desire,
Leaving the females naked and glowing with the lusts of youth

For the female spirits of the dead pining in bonds of religion;
Run from their fetters reddening, & in long drawn arches sitting:
They feel the nerves of youth renew, and desires of ancient times,
Over their pale limbs as a vine when the tender grape appears

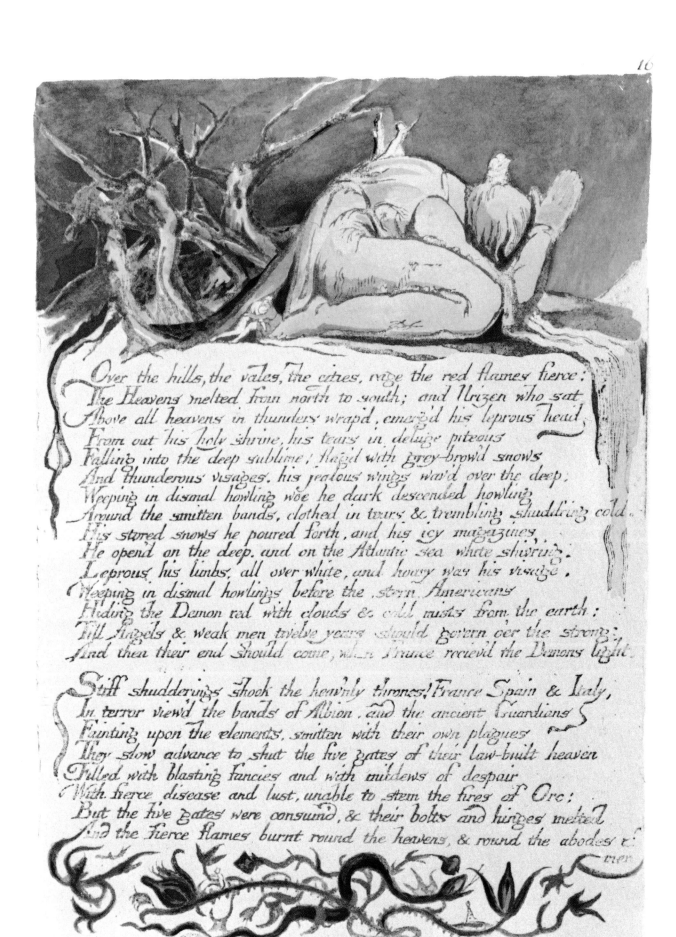

Over the hills, the vales, the cities, rage the red flames fierce:
The Heavens melted from north to south; and Urizen who sat
Above all heavens in thunders wrap'd, emerg'd his leprous head
From out his holy shrine, his tears in deluge piteous
Falling into the deep sublime! flag'd with grey-brow'd snows
And thunderous visages, his jealous wings wav'd over the deep;
Weeping in dismal howling woe he dark descended howling
Around the smitten bands, clothed in tears & trembling shuddring cold.
His stored snows he poured forth, and his icy magazines
He open'd on the deep, and on the Atlantic sea white shivring.
Leprous his limbs, all over white, and hoary was his visage.
Weeping in dismal howlings before the stern Americans
Hiding the Demon red with clouds & cold mists from the earth:
Till Angels & weak men twelve years should govern o'er the strong:
And then their end should come, when France reciev'd the Demons light.

Still shudderings shook the heav'nly thrones! France Spain & Italy,
In terror view'd the bands of Albion, and the ancient Guardians
Fainting upon the elements, smitten with their own plagues
They slow advance to shut the five gates of their law-built heaven
Filled with blasting fancies and with mildews of despair
With fierce disease and lust, unable to stem the fires of Orc;
But the five gates were consum'd, & their bolts and hinges melted
And the fierce flames burnt round the heavens, & round the abodes of
men

"EUROPE: A PROPHECY"

SUMMARY OF POEM (for full printed text, see page 45)

(PLATES 1 & 2:) The Shadowy Female (the material world) complains about her unceasing travail of gestation and about the fierceness of life, but foresees a salvation-bringing birth. (PLATE 3:) Jesus is born, bringing world peace. Los, masculine spirit of poetry, announces his retirement from activity. (PLATE 4:) Enitharmon (Spiritual Beauty), the consort of Los, becomes activated by moving into the red light of their impetuous son Orc. (PLATE 5:) Enitharmon proclaims the dominion of woman, the sinfulness of sex and joy, and the remoteness (both spatial and temporal) of eternal life (considered by Blake as improper interpretations of Christ's thought by later theologians). (PLATE 8:) Enitharmon calls for her children—Rintrah (righteous wrath) and others—to disseminate her teachings. (PLATE 9a:) Enitharmon sleeps 1800 years (the Christian era up to Blake's day). The council house of the Angels of Albion (England) collapses. (PLATE 9b:) Albion's King visits his serpent-shaped temple at Verulam (symbol of Francis Bacon's materialism). (PLATE 10:) Albion's Angel sees Urizen and his book of bronze (symbolizing restrictive religious and social laws). (PLATE 12:) England is oppressed by the rule of Albion's Angel, who is carrying out Enitharmon's will ("Thou shalt not"), but Albion is burned by flames of revolution (Orc). (PLATE 13:) Albion's Angel wishes to blow the trumpet of the Last Judgment, but is unable to. Finally Isaac Newton (who represents to Blake the pinnacle of materialism) blows the trumpet. Enitharmon wakes. (PLATE 14:) Enitharmon calls for numerous children of hers, who represent the frustration and improper channeling of the sex urge. She also calls for Orc, spirit of revolution. (PLATE 15:) Orc brings violent revolution to France, and Los returns to activity, calling his sons to battle.

BRIEF IDENTIFICATION OF ILLUSTRATIONS

FRONTISPIECE: Urizen determining the bounds of the material world. TITLE PAGE: The serpent of Nature (or, of materialism). PLATE 1: A pilgrim menaced by an assassin. PLATE 2: The "howling terrors . . . Devouring & devourid." PLATE 3: A winged woman (perhaps the Shadowy Female). PLATE 4: Enitharmon uncovers the sleeping Orc. PLATE 5: The demon of war and angels of compassion. PLATE 6: Famine (starving women preparing to cook a dead child). PLATE 7: Plague (the bellman announces the dead-cart). PLATE 8: Invasion (an old man trying to repel it). PLATE 9(a): War trumpets blighting grain. PLATE 9(b): The serpent of materialism. PLATE 10: The priest of organized religion, with papal mitre and bat's wings. PLATE 12: Evil spiders prevail. PLATE 13: Imprisonment. PLATE 14: Insects and serpents. PLATE 15: A family fleeing from war and revolution.

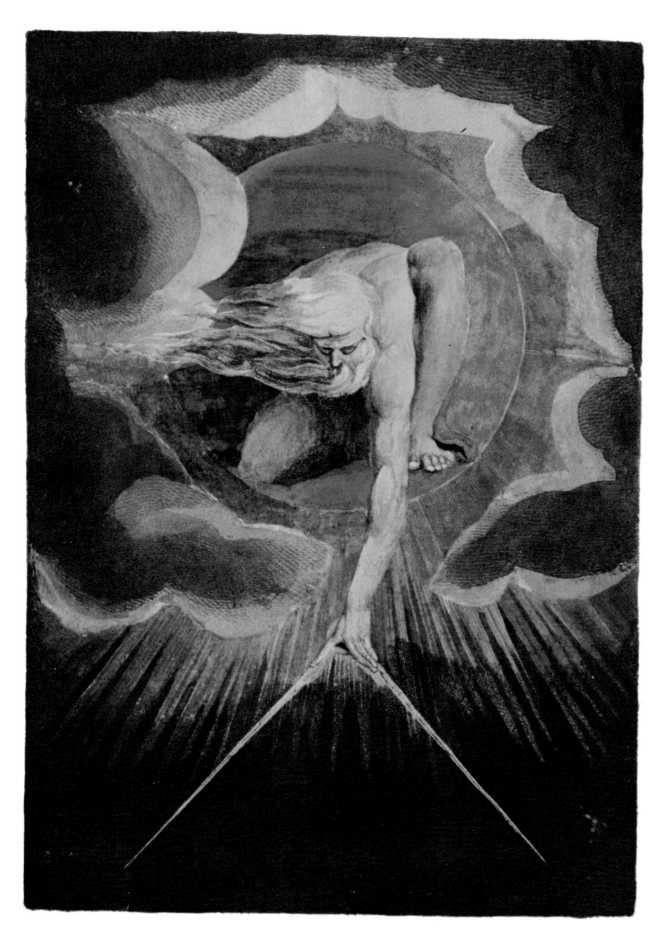

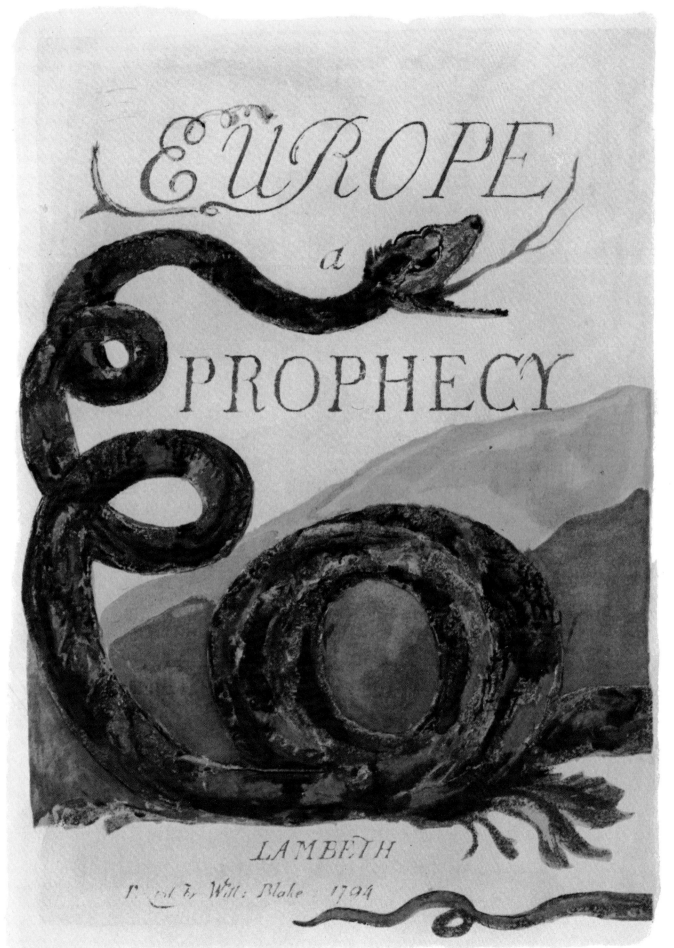

EUROPE

a

PROPHECY

LAMBETH

Printed by Will: Blake 1794

[This prefatory unillustrated monochrome plate was added subsequently by Blake in two copies of *Europe*. It is here reproduced from copy K.]

TRANSCRIPTION:

Five windows light the cavern'd Man: thro' one he breathes the air:
Thro' one hears music of the spheres: thro' one, the eternal vine
Flourishes, that he may recieve the grapes; thro' one can look
And see small portions of the eternal world that ever groweth;
Thro' one himself pass out what time he please; but he will not:
For stolen joys are sweet, & bread eaten in secret pleasant.
So sang a Fairy mocking as he sat on a streak'd Tulip,
Thinking none saw him: when he ceas'd I started from the trees
And caught him in my hat as boys knock down a butterfly.
How know you this said I small Sir? where did you learn this
 song
Seeing himself in my possession thus he answerd me:
My master, I am yours. command me, for I must obey.
Then tell me, what is the material world, and is it dead?
He laughing answer'd: I will write a book on leaves of flowers,
If you will feed me on love-thoughts, & give me now and then
A cup of sparkling poetic fancies: so when I am tipsie,
I'll sing to you to this soft lute: and shew you all alive
The world, when every particle of dust breathes forth its joy.
I took him home in my warm bosom: as we went along
Wild flowers I gatherd: & he shew'd me each eternal flower:
He laugh'd aloud to see them whimper because they were pluck'd.
They hover'd round me like a cloud of incense: when I came
Into my parlour and sat down, and took my pen to write,
My Fairy sat upon the table and dictated EUROPE.

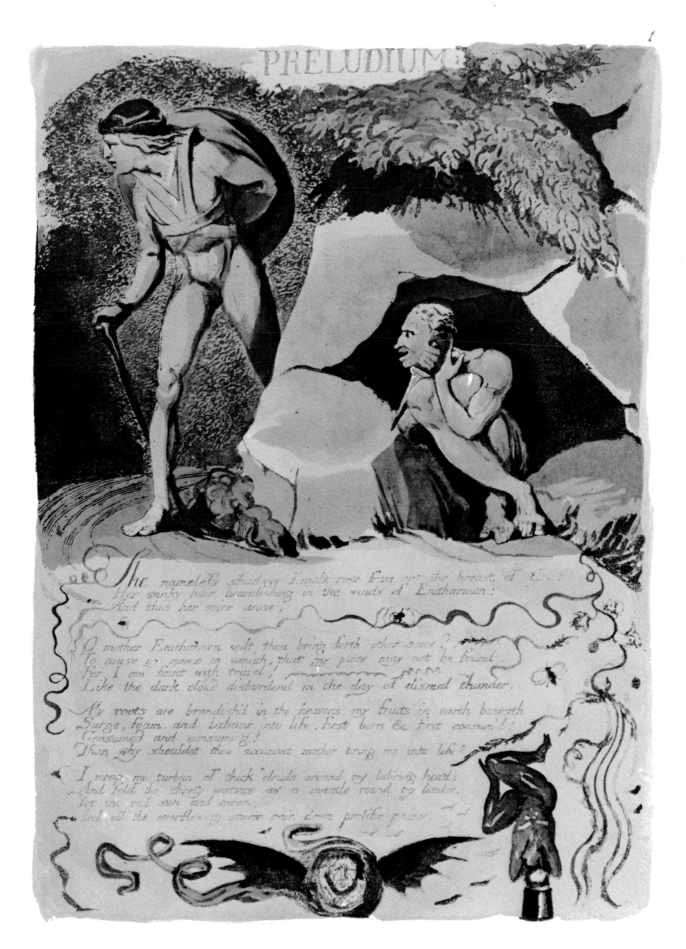

PRELUDIUM

The nameless shadowy female rose from out the breast of Orc
Her snaky hair brandishing in the winds of Enitharmon;
And thus her voice arose.

O mother Enitharmon wilt thou bring forth other sons?
To cause my name to vanish, that my place may not be found.
For I am faint with travel!
Like the dark cloud disburden'd in the day of dismal thunder.

My roots are brandish'd in the heavens, my fruits in earth beneath
Surge, foam, and labour into life, first born & first consum'd!
Consumed and consuming!
Then why shouldst thou accursed mother bring me into life?

I wrap my turban of thick clouds around my lab'ring head;
And fold the sheety waters as a mantle round my limbs.
Yet the red sun and moon,
And all the overflowing stars rain down prolific pains.

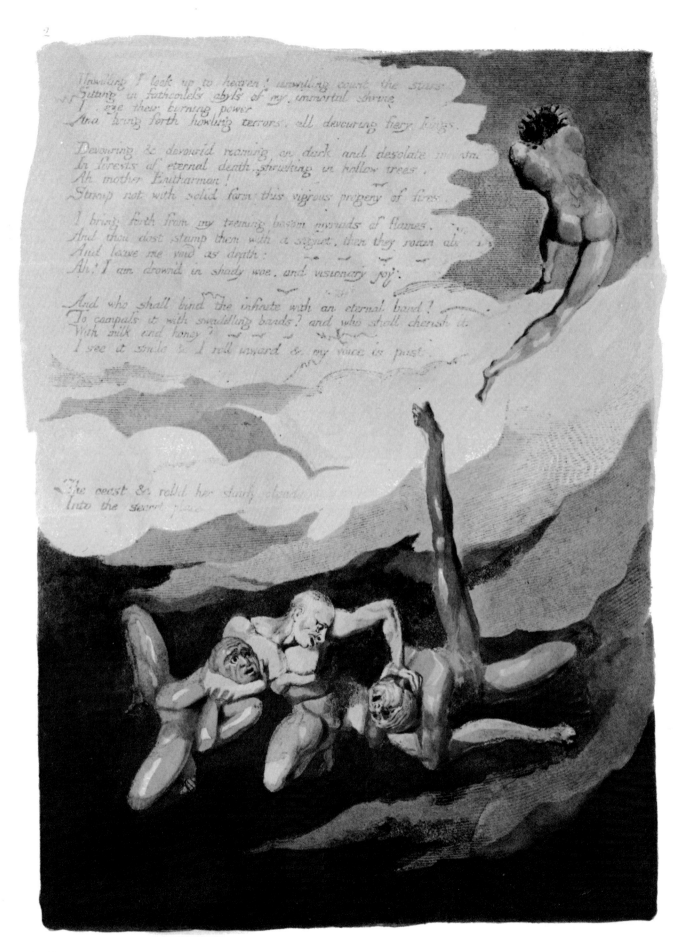

Howling I lookd up to heaven! howling ceasd the stars
Sitting in fathomless abyss of my immortal shrine.
I seize their burning power
And bring forth howling terrors, all devouring fiery kings.

Devouring & devoured roaming on dark and desolate mountains
In forests of eternal death, shrieking in hollow trees.
Ah mother Enitharmon!
Stamp not with solid form this vigrous progeny of fires.

I bring forth from my teeming bosom myriads of flames.
And thou dost stamp them with a signet, then they roam abroad
And leave me void as death:
Ah! I am drown'd in shady woe, and visionary joy.

And who shall bind the infinite with an eternal band?
To compass it with swaddling bands? and who shall cherish it
With milk and honey?
I see it smile & I roll inward & my voice is past.

She ceast & rolld her shady clouds
Into the secret place.

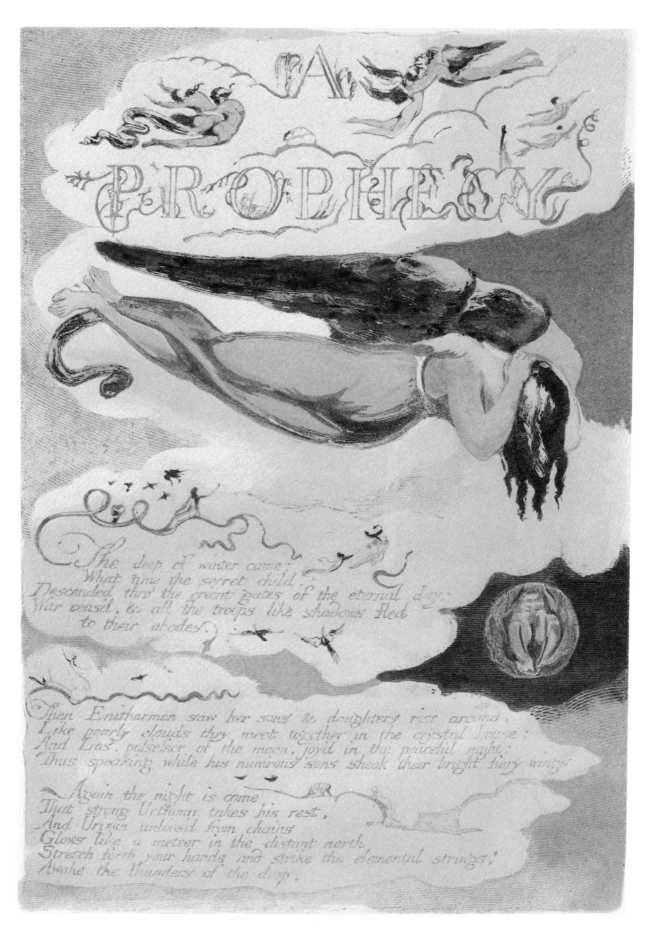

A PROPHECY

The deep of winter came;
What time the secret child,
Descended thro' the orient gates of the eternal day:
War ceas'd, & all the troops like shadows fled
to their abodes.

Then Enitharmon saw her sons & daughters rise around,
Like pearly clouds they meet together in the crystal house;
And Los, possessor of the moon, joy'd in the peaceful night:
Thus speaking while his numerous sons shook their bright fiery wings

Again the night is come
That strong Urthona takes his rest,
And Urizen unloos'd from chains
Glows like a meteor in the distant north
Stretch forth your hands and strike the elemental strings;
Awake the thunders of the deep.

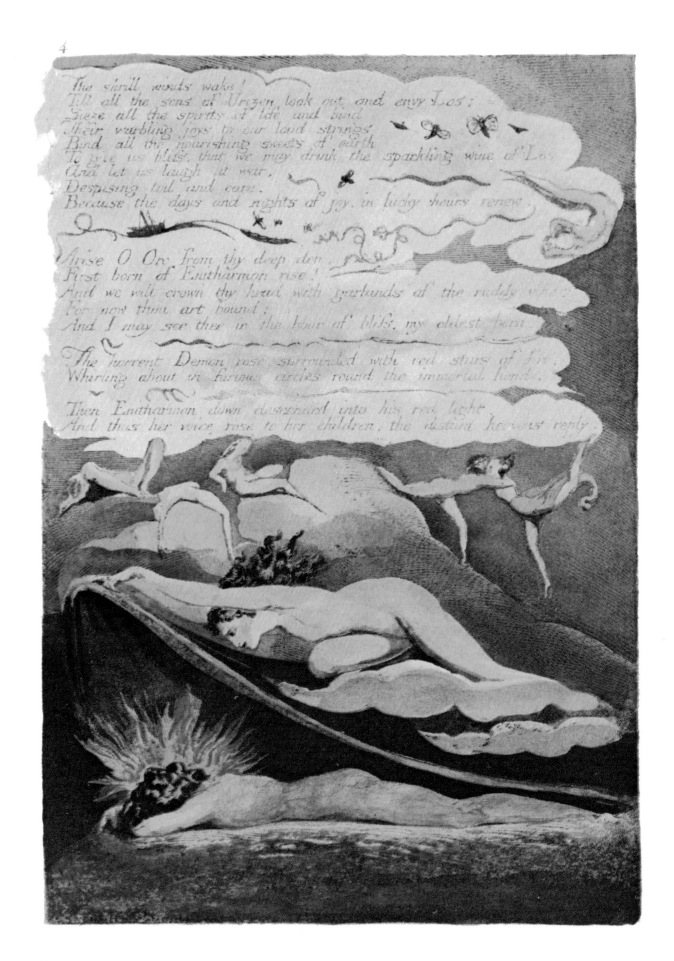

The shrill winds wake!
Till all the sons of Urizen look out and envy Los:
Seize all the spirits of life and bind
Their warbling joys to our loud strings
Bind all the nourishing sweets of earth
To give us bliss, that we may drink the sparkling wine of Los
And let us laugh at war,
Despising toil and care.
Because the days and nights of joy, in lucky hours renew.

Arise O Orc from thy deep den,
First born of Enitharmon rise!
And we will crown thy head with garlands of the ruddy vine;
For now thou art bound;
And I may see thee in the hour of bliss, my eldest born.

The horrent Demon rose, surrounded with red stars of fire,
Whirling about in furious circles round the immortal fiend.

Then Enitharmon down descended into his red light,
And thus her voice rose to her children, the distant heavens reply.

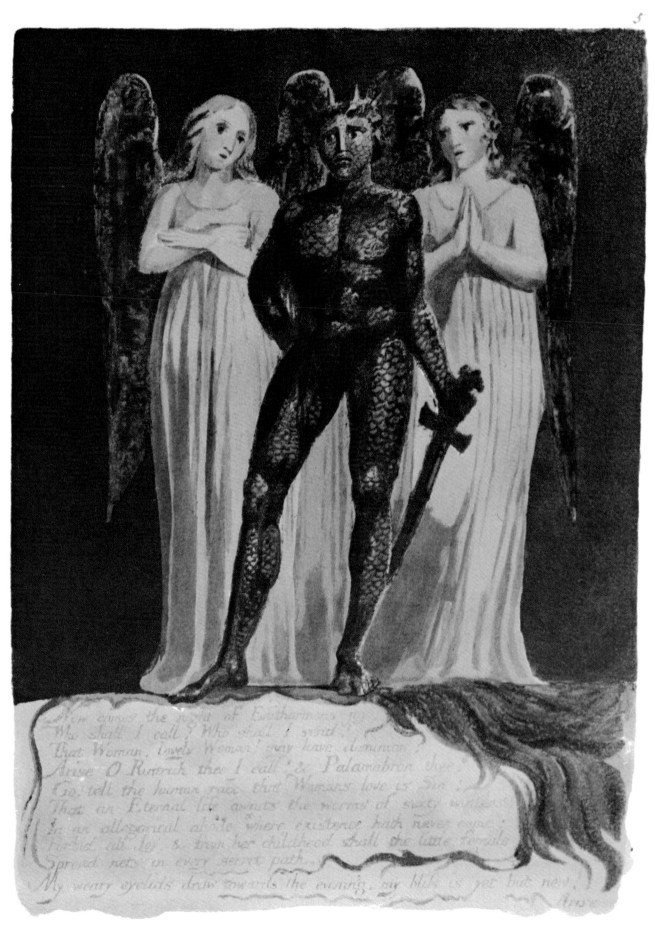

Now comes the night of Enitharmon's joy!
Who shall I call? Who shall I send?
That Woman, lovely Woman! may have dominion?
Arise O Rintrah thee I call! & Palamabron thee!
Go! tell the human race that Womans love is Sin!
That an Eternal life awaits the worms of sixty winters
In an allegorical abode where existence hath never come:
Forbid all Joy, & from her childhood shall the little female
Spread nets in every secret path.

My weary eyelids draw towards the evening, my bliss is yet but new.

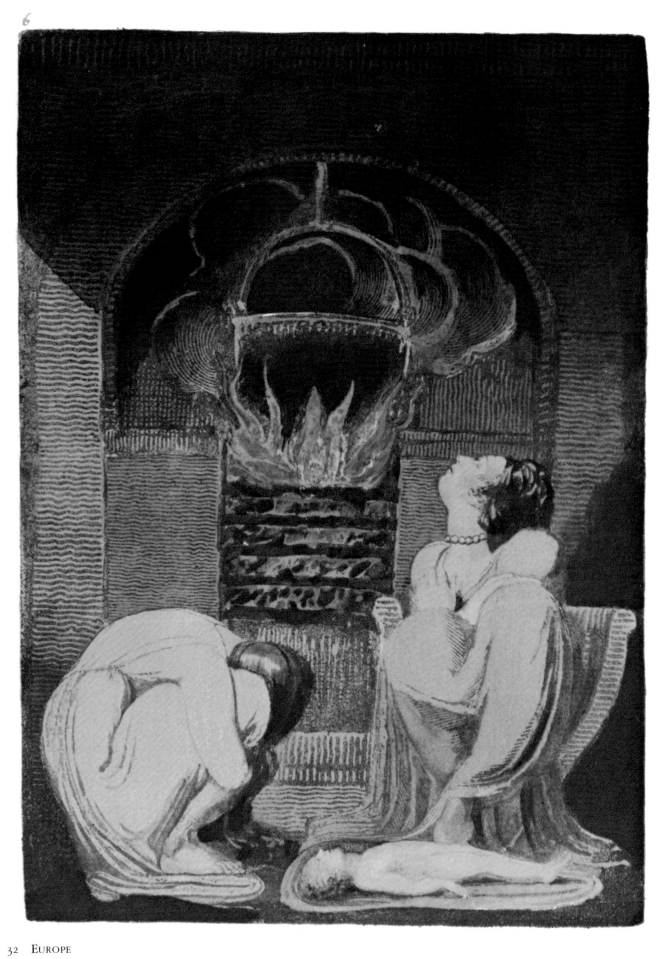

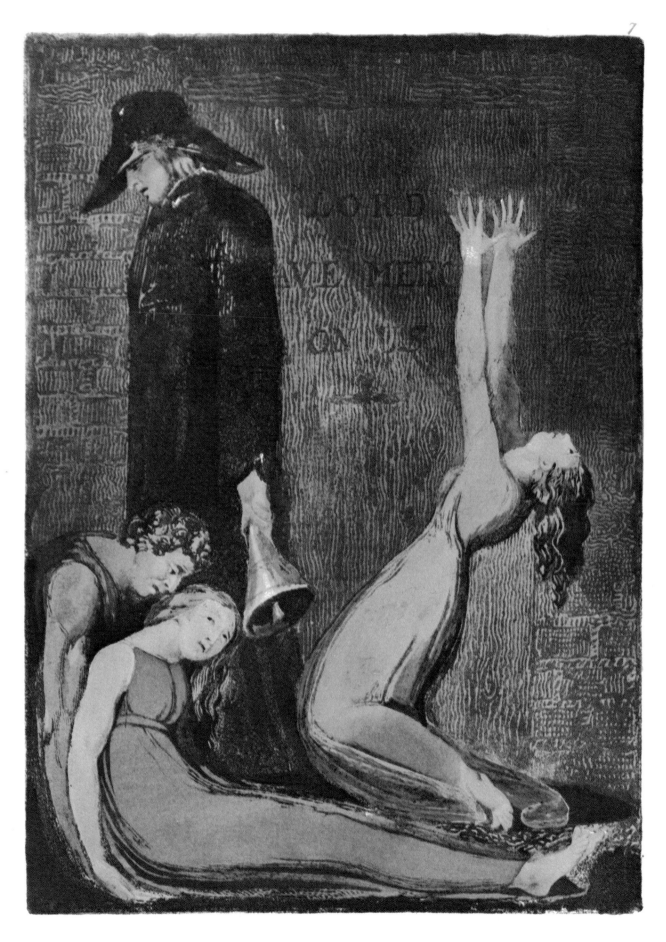

Arise O Rintrah, eldest born, second to none but Orc:
O lion Rintrah raise thy fury from thy forests black:
Bring Palamabron horned priest, skipping upon the mountains:
And silent Elynittria the silver bowed queen:
Rintrah where hast thou hid thy bride:
Weeps she in desart shades?
Alas my Rintrah! bring the lovely jealous Ocalythron.

Arise my son: bring all thy brethren, O thou king of fire.
Prince of the sun I see thee with thy innumerable race:
Thick as the summer stars:
But each ramping his golden mane shakes.
And thine eyes rejoice because of strength O Rintrah furious king.

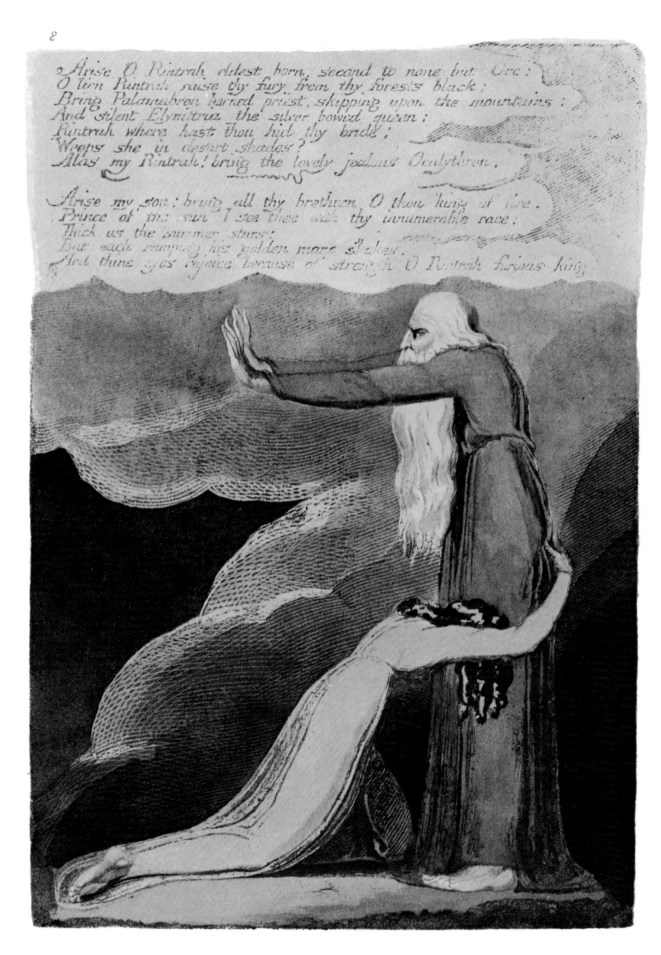

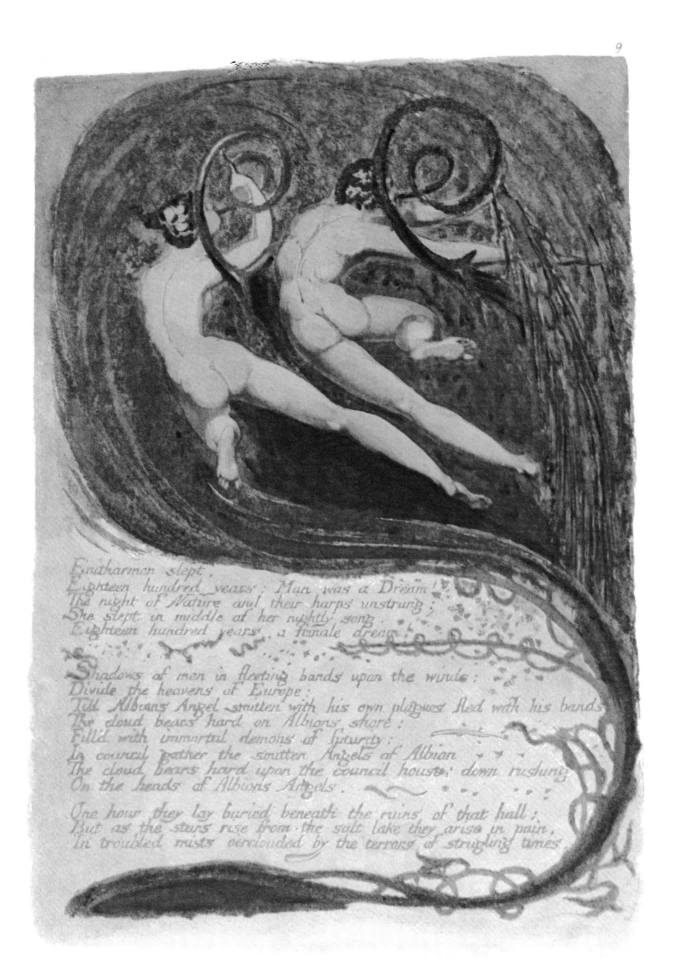

Enitharmon slept,
Eighteen hundred years; Man was a Dream!
The night of Nature and their harps unstrung;
She slept in middle of her nightly song,
Eighteen hundred years, a female dream!

Shadows of men in fleeting bands upon the winds:
Divide the heavens of Europe:
Till Albions Angel smitten with his own plagues fled with his bands
The cloud bears hard on Albions shore:
Fill'd with immortal demons of futurity:
In council gather the smitten Angels of Albion
The cloud bears hard upon the council house; down rushing
On the heads of Albions Angels.

One hour they lay buried beneath the ruins of that hall;
But as the stars rise from the salt lake they arise in pain,
In troubled mists oerclouded by the terrors of struggling times

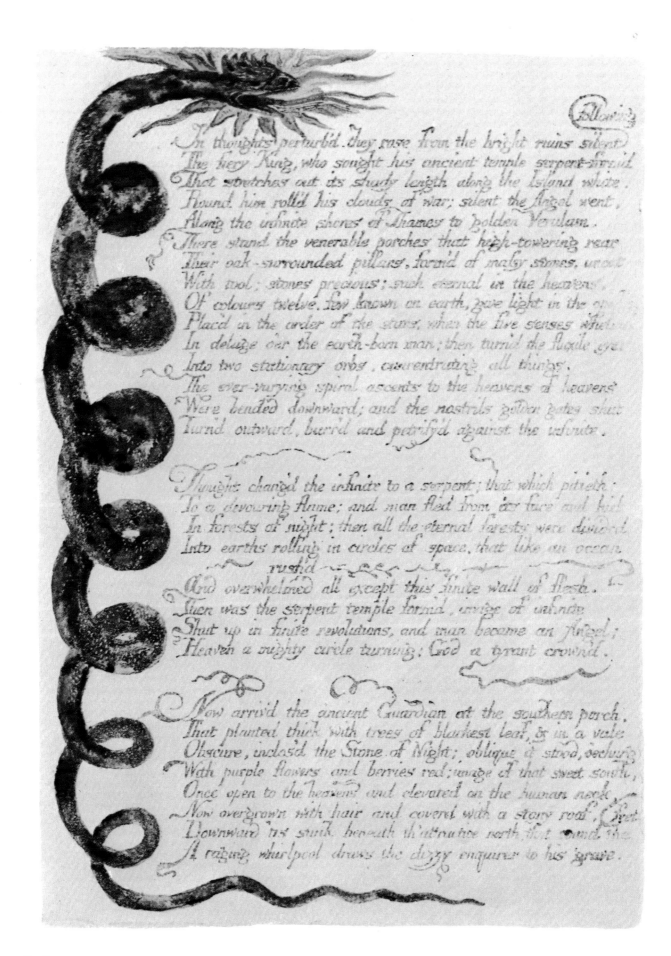

In thoughts perturb'd, they rose from the bright ruins silent
The fiery King, who sought his ancient temple serpent-form'd
That stretches out its shady length along the Island white.
Round him roll'd his clouds of war; silent the Angel went,
Along the infinite shores of Thames to golden Verulam.
There stand the venerable porches that high-towering rear
Their oak-surrounded pillars, form'd of massy stones, uncut
With tool; stones precious; such eternal in the heavens,
Of colours twelve, few known on earth, give light in the opake
Placed in the order of the stars, when the five senses whelm'd
In deluge o'er the earth-born man; then turn'd the fluxile eyes
Into two stationary orbs, concentrating all things.
The ever-varying spiral ascents to the heavens of heavens
Were bended downward; and the nostrils golden gates shut
Turn'd outward, barr'd and petrify'd against the infinite.

Thought chang'd the infinite to a serpent; that which pitieth;
To a devouring flame; and man fled from its face and hid
In forests of night; then all the eternal forests were divided
Into earths rolling in circles of space, that like an ocean
rush'd
And overwhelmed all except this finite wall of flesh.
Then was the serpent temple form'd, image of infinite
Shut up in finite revolutions, and man became an Angel;
Heaven a mighty circle turning; God a tyrant crown'd.

Now arriv'd the ancient Guardian at the southern porch,
That planted thick with trees of blackest leaf, & in a vale
Obscure, enclos'd the Stone of Night; oblique it stood, o'erhung
With purple flowers and berries red; image of that sweet south,
Once open to the heavens and elevated on the human neck,
Now overgrown with hair and cover'd with a stony roof,
Downward 'tis sunk beneath th'attractive north, that round the
A raging whirlpool draws the dizzy enquirer to his grave.

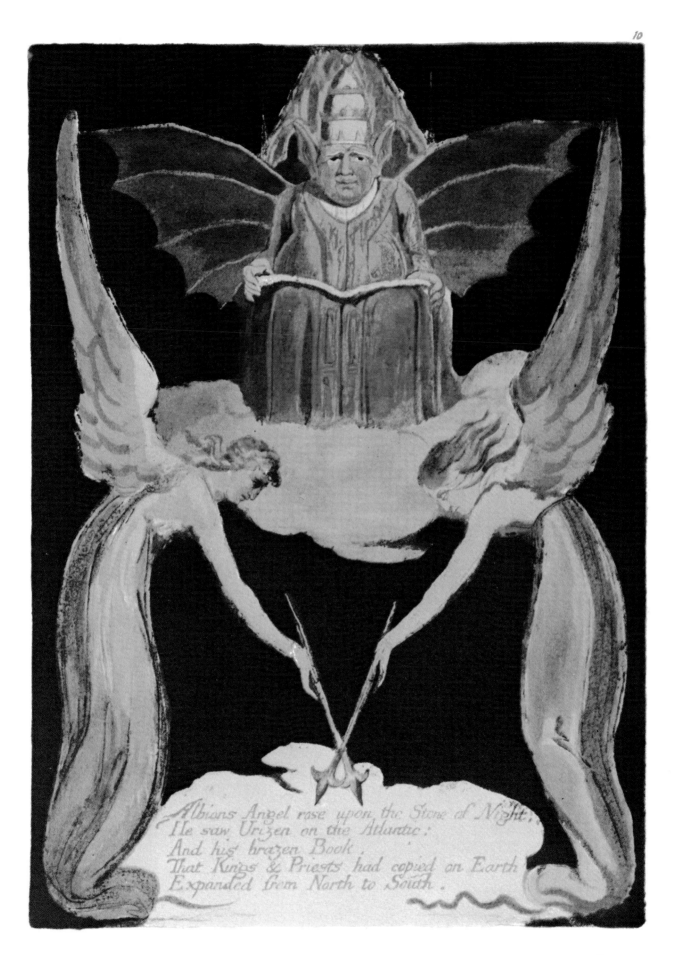

Albions Angel rose upon the Stone of Night,
He saw Urizen on the Atlantic;
And his brazen Book,
That Kings & Priests had copied on Earth
Expanded from North to South.

EUROPE 37

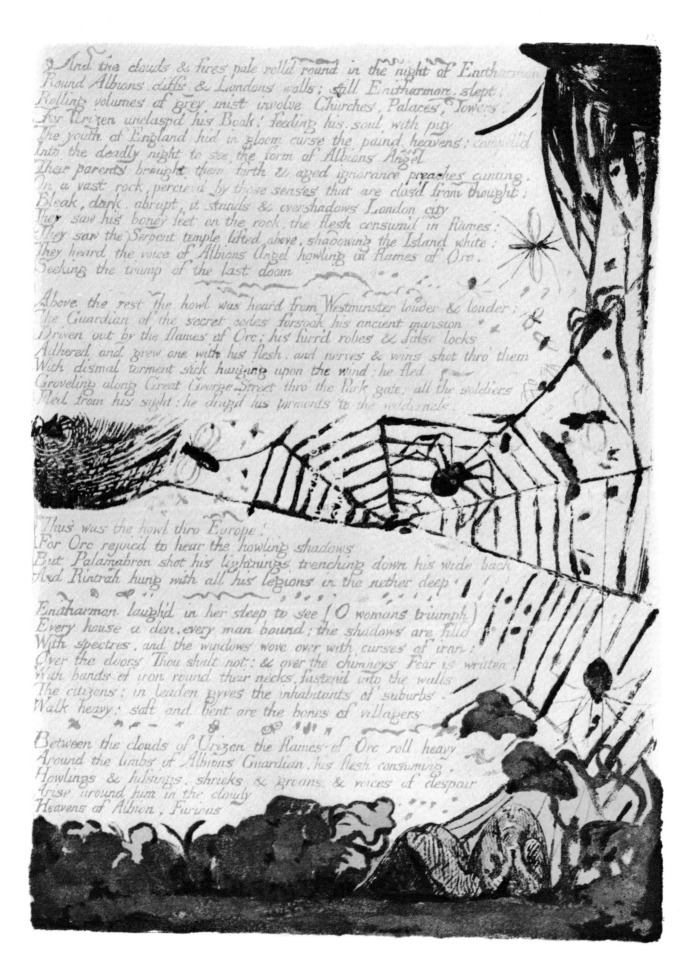

And the clouds & fires pale roll'd round in the night of Enitharmon
Round Albions cliffs & Londons walls; still Enitharmon slept:
Rolling volumes of grey mist involve Churches, Palaces, Towers:
For Urizen unclaspd his Book! feeding his soul with pity
The youth of England hid in gloom curse the pained heavens; compell'd
Into the deadly night to see the form of Albions Angel
Their parents brought them forth & aged ignorance preaches canting.
On a vast rock, perciev'd by those senses that are clos'd from thought:
Bleak, dark, abrupt, it stands & overshadows London city
They saw his boney feet on the rock, the flesh consum'd in flames:
They saw the Serpent temple lifted above, shadowing the Island white:
They heard the voice of Albions Angel howling in flames of Orc,
Seeking the trump of the last doom

Above the rest the howl was heard from Westminster louder & louder:
The Guardian of the secret codes forsook his ancient mansion
Driven out by the flames of Orc; his furr'd robes & false locks
Adhered and grew one with his flesh, and nerves & veins shot thro' them
With dismal torment sick hanging upon the wind: he fled
Groveling along Great George Street thro' the Park gate; all the soldiers
Fled from his sight: he dragd his torments to the wilderness.

Thus was the howl thro' Europe!
For Orc rejoic'd to hear the howling shadows
But Palamabron shot his lightnings trenching down his wide back
And Rintrah hung with all his legions in the nether deep

Enitharmon laugh'd in her sleep to see (O womans triumph)
Every house a den, every man bound; the shadows are fill'd
With spectres, and the windows wove over with curses of iron:
Over the doors Thou shalt not; & over the chimneys Fear is written:
With bands of iron round their necks fasten'd into the walls
The citizens: in leaden gyves the inhabitants of suburbs
Walk heavy: soft and bent are the bones of villagers

Between the clouds of Urizen the flames of Orc roll heavy
Around the limbs of Albions Guardian, his flesh consuming.
Howlings & hissings, shrieks & groans, & voices of despair
Arise around him in the cloudy
Heavens of Albion, Furious

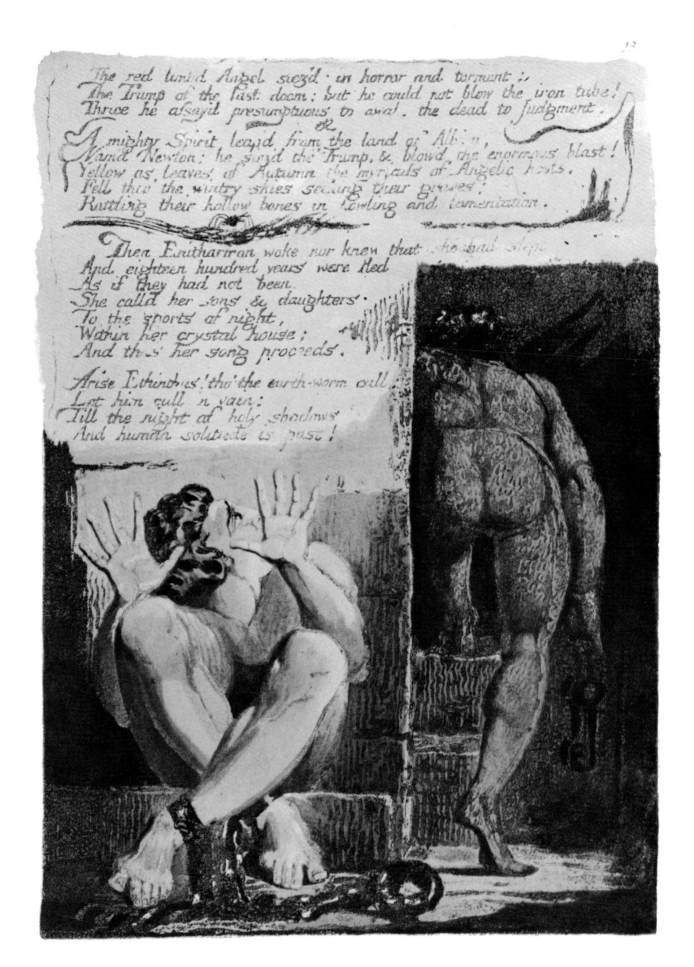

The red limb'd Angel siez'd. in horror and torment:
The Trump of the last doom: but he could not blow the iron tube!
Thrice he assay'd presumptuous to awake the dead to judgment.

A mighty Spirit leap'd from the land of Albion,
Nam'd Newton: he siez'd the Trump, & blow'd the enormous blast!
Yellow as leaves of Autumn the myriads of Angelic hosts,
Fell thro' the wintry skies seeking their graves:
Rattling their hollow bones in howling and lamentation.

Then Enitharmon woke nor knew that she had slept
And eighteen hundred years were fled
As if they had not been.
She calld her sons & daughters.
To the sports of night,
Within her crystal house;
And thus her song proceeds.

Arise Ethinthus! tho' the earth-worm call:
Let him call in vain;
Till the night of holy shadows
And human solitude is past!

Ethinthus queen of waters, how thou shinest in the sky:
My daughter how do I rejoice! for thy children flock around
Like the gay fishes on the wave, when the cold moon drinks the dew
Ethinthus! thou art sweet as comforts to my fainting soul:
For now thy waters warble round the feet of Enitharmon.

Manathu-Vorcyon! I behold thee flaming in my halls,
Light of thy mothers soul! I see thy lovely eagles round:
Thy golden wings are my delight, & thy flames of soft delusion.

Where is my lureing bird of Eden! Leutha silent love!
Leutha, the many coloured bow delights upon thy wings:
Soft soul of flowers Leutha!
Sweet smiling pestilence! I see thy blushing light:
Thy daughters many changing,
Revolve like sweet perfumes ascending O Leutha silken queen!

Where is the youthful Antamon, prince of the pearly dew.
O Antamon, why wilt thou leave thy mother Enitharmon?
Alone I see thee crystal form,
Floting upon the bosomd air:
With lineaments of gratified desire.
My Antamon the seven churches of Leutha seek thy love.

I hear the soft Oothoon in Enitharmons tents:
Why wilt thou give up womans secrecy my melancholy child?
Between two moments bliss is ripe:
O Theotormon robb'd of joy, I see thy salt tears flow
Down the steps of my crystal house.

Sotha & Thiralatha, secret dwellers of dreamful caves,
Arise and please the horrent fiend with your melodious songs.
Still all your thunders golden hoofd, & bind your horses black.
Orc! smile upon my children!
Smile son of my afflictions.
Arise O Orc and give our mountains joy of thy red light.

She ceas'd, for All were forth at sport beneath the solemn moon
Waking the stars of Urizen with their immortal songs,
That nature felt thro' all her pores the enormous revelry,
Till morning ope'd the eastern gate.
Then every one fled to his station, & Enitharmon wept.

But terrible Orc, when he beheld the morning in the east

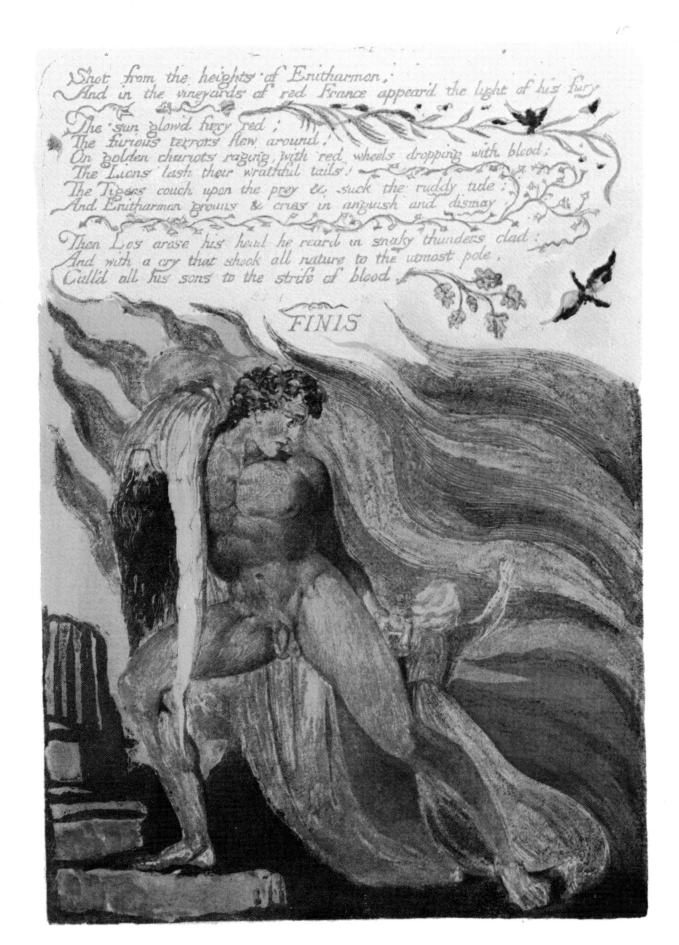

Shot from the heights of Enitharmon;
And in the vineyards of red France appeard the light of his fury

The sun glowd fiery red;
The furious terrors flew around!
On golden chariots raging, with red wheels dropping with blood:
The Lions lash their wrathful tails!
The Tigers couch upon the prey & suck the ruddy tide:
And Enitharmon groans & cries in anguish and dismay.

Then Los arose his head he reard in snaky thunders clad:
And with a cry that shook all nature to the utmost pole,
Calld all his sons to the strife of blood.

FINIS

THE TEXTS

AMERICA
a PROPHECY
LAMBETH

Printed by William Blake in the year 1793

PLATE 1

PRELUDIUM

The shadowy daughter of Urthona stood before red Orc,
When fourteen suns had faintly journey'd o'er his dark abode;
His food she brought in iron baskets, his drink in cups of iron.
Crown'd with a helmet & dark hair the nameless female stood;
A quiver with its burning stores, a bow like that of night,
When pestilence is shot from heaven: no other arms she need:
Invulnerable tho' naked, save where clouds roll round her loins
Their awful folds in the dark air: silent she stood as night:
For never from her iron tongue could voice or sound arise;
But dumb till that dread day when Orc assay'd his fierce embrace.
Dark Virgin: said the hairy youth, thy father stern abhorr'd,
Rivets my tenfold chains while still on high my spirit soars;
Sometimes an eagle screaming in the sky, sometimes a lion
Stalking upon the mountains, & sometimes a whale I lash
The raging fathomless abyss, anon a serpent folding
Around the pillars of Urthona, and round thy dark limbs,
On the Canadian wilds I fold, feeble my spirit folds.
For chaind beneath I rend these caverns: when thou bringest food
I howl my joy, and my red eyes seek to behold thy face
In vain! these clouds roll to & fro, & hide thee from my sight.

PLATE 2

Silent as despairing love, and strong as jealousy,
The hairy shoulders rend the links, free are the wrists of fire;
Round the terrific loins he siez'd the panting, struggling womb;
It joy'd: she put aside her clouds & smiled her first-born smile,
As when a black cloud shews its light'nings to the silent deep.
Soon as she saw the terrible boy then burst the virgin cry.
I know thee, I have found thee, & I will not let thee go:
Thou art the image of God who dwells in darkness of Africa,
And thou art fall'n to give me life in regions of dark death.
On my American plains I feel the struggling afflictions
Endur'd by roots that writhe their arms into the nether deep:
I see a Serpent in Canada who courts me to his love,
In Mexico an Eagle, and a Lion in Peru;
I see a Whale in the South-sea, drinking my soul away.
O what limb rending pains I feel, thy fire & my frost
Mingle in howling pains, in furrows by thy lightnings rent;
This is eternal death; and this the torment long foretold.
The stern Bard ceas'd, asham'd of his own song; enrag'd he swung
His harp aloft sounding, then dash'd its shining frame against
A ruin'd pillar in glitt'ring fragments; silent he turn'd away,
And wander'd down the vales of Kent in sick & drear lamentings.

PLATE 3

A PROPHECY

The Guardian Prince of Albion burns in his nightly tent.
Sullen fires across the Atlantic glow to America's shore
Piercing the souls of warlike men who rise in silent night.
Washington, Franklin, Paine & Warren, Gates, Hancock & Green
Meet on the coast glowing with blood from Albions fiery Prince.
Washington spoke: Friends of America! look over the Atlantic
 sea;
A bended bow is lifted in heaven, & a heavy iron chain
Descends link by link from Albions cliffs across the sea, to bind
Brothers & sons of America, till our faces pale and yellow,
Heads deprest, voices weak, eyes downcast, hands work-bruis'd,
Feet bleeding on the sultry sands, and the furrows of the whip
Descend to generations that in future times forget.—
The strong voice ceas'd; for a terrible blast swept over the heaving
 sea,
The eastern cloud rent: on his cliffs stood Albions wrathful Prince
A dragon form clashing his scales at midnight he arose,
And flam'd red meteors round the land of Albion beneath.
His voice, his locks, his awful shoulders, and his glowing eyes

PLATE 4

Appear to the Americans upon the cloudy night.
Solemn heave the Atlantic waves between the gloomy nations
Swelling, belching from its deeps red clouds & raging fires,
Albion is sick. America faints! Enrag'd the Zenith grew.
As human blood shooting its veins all round the orbed heaven,
Red rose the clouds from the Atlantic in vast wheels of blood
And in the red clouds rose a Wonder o'er the Atlantic sea;
Intense! naked! a Human fire, fierce glowing, as the wedge
Of iron heated in the furnace: his terrible limbs were fire
With myriads of cloudy terrors, banners dark & towers
Surrounded: heat but not light went thro' the murky atmosphere.
The King of England looking westward trembles at the vision.

PLATE 5

Albions Angel stood beside the Stone of night, and saw
The terror like a comet, or more like the planet red
That once inclos'd the terrible wandering comets in its sphere.
Then Mars thou wast our center, & the planets three flew round
Thy crimson disk: so e'er the Sun was rent from thy red sphere;
The Spectre glow'd his horrid length staining the temple long
With beams of blood; & thus a voice came forth, and shook the
 temple

PLATE 6

The morning comes, the night decays, the watchmen leave their
 stations;
The grave is burst, the spices shed, the linen wrapped up;
The bones of death, the covring clay, the sinews shrunk & dry'd
Reviving shake, inspiring move, breathing! awakening!

Spring like redeemed captives when their bonds & bars are burst;
Let the slave grinding at the mill, run out into the field:
Let him look up into the heavens & laugh in the bright air;
Let the inchained soul shut up in darkness and in sighing,
Whose face has never seen a smile in thirty weary years,
Rise and look out, his chains are loose, his dungeon doors are
 open.
And let his wife and childen return from the oppressors scourge;
They look behind at every step & believe it is a dream,
Singing, The Sun has left his blackness & has found a fresher
 morning
And the fair Moon rejoices in the clear & cloudless night;
For Empire is no more, and now the Lion & Wolf shall cease.

PLATE 7

In thunders ends the voice. Then Albions Angel wrathful burnt
Beside the Stone of Night, and like the Eternal Lions howl
In famine & war, reply'd, Art thou not Orc, who serpent-form'd
Stands at the gate of Enitharmon to devour her children;
Blasphemous Demon, Antichrist, hater of Dignities;
Lover of wild rebellion, and transgressor of God's Law;
Why dost thou come to Angels eyes in this terrific form?

PLATE 8

The terror answerd: I am Orc, wreath'd round the accursed tree:
The times are ended: shadows pass the morning 'gins to break;
The fiery joy, that Urizen perverted to ten commands,
What night he led the starry hosts thro' the wide wilderness,
That stony law I stamp to dust: and scatter religion abroad
To the four winds as a torn book, & none shall gather the leaves.
But they shall rot on desart sands, & consume in bottomless
 deeps,
To make the desarts blossom, & the deeps shrink to their foun-
 tains,
And to renew the fiery joy, and burst the stony roof.
That pale religious letchery, seeking Virginity,
May find it in a harlot, and in coarse-clad honesty
The undefil'd tho' ravish'd in her cradle night and morn:
For every thing that lives is holy, life delights in life:
Because the soul of sweet delight can never be defil'd.
Fires inwrap the earthly globe, yet man is not consumd;
Amidst the lustful fires he walks; his feet become like brass,
His knees and thighs like silver, & his breast and head like gold.

PLATE 9

Sound! sound! my loud war-trumpets, & alarm my Thirteen
 Angels!
Loud howls the eternal Wolf! the eternal Lion lashes his tail!
America is darkned; and my punishing Demons terrified
Crouch howling before their caverns deep, like skins dry'd in the
 wind.
They cannot smite the wheat, nor quench the fatness of the earth.
They cannot smite with sorrows, nor subdue the plow and spade.
They cannot wall the city, nor moat round the castle of princes.
They cannot bring the stubbed oak to overgrow the hills.
For terrible men stand on the shores; & in their robes I see
Children take shelter from the lightnings, there stands Washing-
 ton
And Paine and Warren with their foreheads reard toward the east
But clouds obscure my aged sight. A vision from afar!
Sound! Sound! my loud war-trumpets & alarm my thirteen
 Angels:

Ah vision from afar! Ah rebel form that rent the ancient
Heavens, Eternal Viper self-renew'd, rolling in clouds
I see thee in thick clouds and darkness on America's shore.
Writhing in pangs of abhorred birth; red flames the crest rebel-
 lious
And eyes of death; the harlot womb, oft opened in vain
Heaves in enormous circles, now the times are return'd upon thee,
Devourer of thy parent, now thy unutterable torment renews.
Sound! sound! my loud war trumpets & alarm my thirteen Angels.
Ah terrible birth! a young one bursting! where is the weeping
 mouth?
And where the mothers milk? instead those ever-hissing jaws
And parched lips drop with fresh gore; now roll thou in the
 clouds
Thy mother lays her length outstretch'd upon the shore beneath.
Sound! sound! my loud war-trumpets & alarm my thirteen Angels!
Loud howls the eternal Wolf! the eternal Lion lashes his tail!

PLATE 10

Thus wept the Angel voice & as he wept the terrible blasts
Of trumpets, blew a loud alarm across the Atlantic deep.
No trumpets answer; no reply of clarions or of fifes,
Silent the Colonies remain and refuse the loud alarm.
On those vast shady hills between America & Albions shore,
Now barr'd out by the Atlantic sea: call'd Atlantean hills
Because from their bright summits you may pass to the Golden
 world,
An ancient palace, archetype of mighty Emperies,
Rears its immortal pinnacles, built in the forest of God
By Ariston the king of beauty for his stolen bride.
Here on their magic seats the thirteen Angels sat perturb'd,
For clouds from the Atlantic hover o'er the solemn roof.

PLATE 11

Fiery the Angels rose, & as they rose deep thunder roll'd
Around their shores: indignant burning with the fires of Orc
And Bostons Angel cried aloud as they flew thro' the dark night.
He cried: Why trembles honesty, and like a murderer,
Why seeks he refuge from the frowns of his immortal station.
Must the generous tremble & leave his joy to the idle: to the pes-
 tilence!
That mock him? who commanded this? what God? what Angel?
To keep the gen'rous from experience till the ungenerous
Are unrestraind performers of the energies of nature;
Till pity is become a trade, and generosity a science
That men get rich by, & the sandy desert is giv'n to the strong
What God is he, writes laws of peace & clothes him in a tempest
What pitying Angel lusts for tears, and fans himself with sighs
What crawling villain preaches abstinence & wraps himself
In fat of lambs? no more I follow, no more obedience pay.

PLATE 12

So cried he, rending off his robe & throwing down his scepter,
In sight of Albions Guardian, and all the thirteen Angels
Rent off their robes to the hungry wind, & threw their golden
 scepters
Down on the land of America; indignant they descended
Headlong from out their heav'nly heights, descending swift as
 fires
Over the land: naked & flaming are their lineaments seen
In the deep gloom, by Washington & Paine & Warren they stood
And the flame folded roaring fierce within the pitchy night

43

Before the Demon red, who burnt towards America,
In black smoke thunders and loud winds, rejoicing in its terror
Breaking in smoky wreaths from the wild deep & gath'ring thick
In flames as of a furnace on the land from North to South

PLATE 13

What time the thirteen Governors that England sent convene
In Bernards house; the flames cover'd the land, they rouze they cry
Shaking their mental chains they rush in fury to the sea
To quench their anguish; at the feet of Washington down fall'n
They grovel on the sand and writhing lie, while all
The British soldiers thro' the thirteen states sent up a howl
Of anguish: threw their swords & muskets to the earth, & run
From their encampments and dark castles seeking where to hide
From the grim flames; and from the visions of Orc; in sight
Of Albions Angel; who enrag'd his secret clouds open'd
From north to south and burnt outstretchd on wings of wrath
 cov'ring
The eastern sky, spreading his awful wings across the heavens:
Beneath him rolld his num'rous hosts, all Albions Angels camp'd
Darkend the Atlantic mountains & their trumpets shook the val-
 leys
Arm'd with diseases of the earth to cast upon the Abyss,
Their numbers forty millions, must'ring in the eastern sky.

PLATE 14

In the flames stood & view'd the armies drawn out in the sky
Washington Franklin Paine & Warren Allen Gates & Lee
And heard the voice of Albions Angel give the thunderous com-
 mand;
His plagues obedient to his voice flew forth out of their clouds
Falling upon America, as a storm to cut them off
As a blight cuts the tender corn when it begins to appear.
Dark is the heaven above, & cold & hard the earth beneath;
And as a plague wind fill'd with insects cuts off man & beast;
And as a sea o'erwhelms a land in the day of an earthquake;
Fury! rage! madness! in a wind swept through America
And the red flames of Orc that folded roaring fierce around
The angry shores, and the fierce rushing of th' inhabitants to-
 gether!
The citizens of New-York close their books & lock their chests:
The mariners of Boston drop their anchors and unlade;
The scribe of Pensylvania casts his pen upon the earth;
The builder of Virginia throws his hammer down in fear.
Then had America been lost, o'erwhelm'd by the Atlantic,
And Earth had lost another portion of the infinite,
But all rush together in the night in wrath and raging fire.
The red fires rag'd! the plagues recoil'd! then rolld they back with
 fury

PLATE 15

On Albion's Angels: then the Pestilence began in streaks of red
Across the limbs of Albions Guardian; the spotted plague smote
 Bristols
And the Leprosy Londons Spirit, sickening all their bands:
The millions sent up a howl of anguish and threw off their ham-
 merd mail,

And cast their swords & spears to earth, & stood a naked multi-
 tude.
Albions Guardian writhed in torment on the eastern sky,
Pale quivring toward the brain his glimmering eyes, teeth chatter-
 ing
Howling & shuddering his legs quivering: convuls'd each muscle
 & sinew
Sick'ning lay London's Guardian, and the ancient miter'd York
Their heads on snowy hills, their ensigns sick'ning in the sky.
The plagues creep on the burning winds driven by flames of Orc,
And by the fierce Americans rushing together in the night
Driven o'er the Guardians of Ireland, and Scotland and Wales.
They spotted with plagues forsook the frontiers & their banners
 seard
With fires of hell, deform their ancient heavens with shame &
 woe.
Hid in his caves the Bard of Albion felt the enormous plagues,
And a cowl of flesh grew o'er his head, & scales on his back & ribs:
And rough with black scales all his Angels fright their ancient
 heavens.
The doors of marriage are open, and the Priests in rustling scales
Rush into reptile coverts, hiding from the fires of Orc,
That play around the golden roofs in wreaths of fierce desire,
Leaving the females naked and glowing with the lusts of youth.
For the female spirits of the dead pining in bonds of religion
Run from their fetters reddening, & in long drawn arches sitting
They feel the nerves of youth renew, and desires of ancient times
Over their pale limbs as a vine when the tender grape appears.

PLATE 16

Over the hills, the vales, the cities, rage the red flames fierce:
The Heavens melted from north to south; and Urizen who sat
Above all heavens in thunders wrap'd: emerg'd his leprous head
From out his holy shrine, his tears in deluge piteous
Falling into the deep sublime; flag'd with grey-brow'd snows
And thunderous visages, his jealous wings wav'd over the deep;
Weeping in dismal howling woe he dark descended howling
Around the smitten bands, clothed in tears & trembling
 shudd'ring cold.
His stored snows he poured forth, and his icy magazines
He open'd on the deep, and on the Atlantic sea white shiv'ring.
Leprous his limbs, all over white, and hoary was his visage,
Weeping in dismal howlings before the stern Americans
Hiding the Demon red with clouds & cold mists from the earth
Till Angels & weak men twelve years should govern o'er the
 strong;
And then their end should come, when France reciev'd the
 Demons light.
Stiff shudderings shook the heav'nly thrones! France Spain & Italy
In terror view'd the bands of Albion, and the ancient Guardians
Fainting upon the elements, smitten with their own plagues
They slow advance to shut the five gates of their law-built heaven
Filled with blasting fancies and with mildews of despair
With fierce disease and lust, unable to stem the fires of Orc:
But the five gates were consum'd, & their bolts and hinges melted
And the fierce flames burnt round the heavens, & round the
 abodes of men.

EUROPE

a PROPHECY

LAMBETH

Printed by Will: Blake, 1794

PLATE 1

PRELUDIUM

The nameless shadowy female rose from out the breast of Orc:
Her snaky hair brandishing in the winds of Enitharmon:
And thus her voice arose:
O mother Enitharmon wilt thou bring forth other sons?
To cause my name to vanish, that my place may not be found.
For I am faint with travel!
Like the dark cloud disburdend in the day of dismal thunder.
My roots are brandish'd in the heavens, my fruits in earth beneath
Surge, foam and labour into life, first born & first consum'd!
Consumed and consuming!
Then why shouldst thou accursed mother bring me into life?
I wrap my turban of thick clouds around my lab'ring head:
And fold the sheety waters as a mantle round my limbs.
Yet the red sun and moon,
And all the overflowing stars rain down prolific pains.

PLATE 2

Unwilling I look up to heaven, unwilling count the stars:
Sitting in fathomless abyss of my immortal shrine
I sieze their burning power
And bring forth howling terrors, all devouring fiery kings,
Devouring & devourid roaming on dark and desolate mountains,
In forests of eternal death, shrieking in hollow trees.
Ah mother Enitharmon!
Stamp not with solid form this vig'rous progeny of fires.
I bring forth from my teeming bosom myriads of flames,
And thou dost stamp them with a signet, then they roam abroad
And leave me void as death:
Ah! I am drown'd in shady woe, and visionary joy.
And who shall bind the infinite with an eternal band?
To compass it with swaddling bands? and who shall cherish it
With milk and honey?
I see it smile & I roll inward & my voice is past.
She ceast & roll'd her shady clouds
Into the secret place.

PLATE 3

A PROPHECY

The deep of winter came:
What time the secret child
Descended thro' the orient gates of the eternal day:
War ceas'd, & all the troops like shadows fled to their abodes.

Then Enitharmon saw her sons & daughters rise around,
Like pearly clouds they meet together in the crystal house;
And Los, possessor of the moon, joy'd in the peaceful night;
Thus speaking while his num'rous sons shook their bright fiery
 wings
Again the night is come
That strong Urthona takes his rest;
And Urizen unloos'd from chains,
Glows like a meteor in the distant north
Stretch forth your hands and strike the elemental strings!
Awake the thunders of the deep.

PLATE 4

The shrill winds wake!
Till all the sons of Urizen look out and envy Los:
Sieze all the spirits of life and bind
Their warbling joys to our loud strings
Bind all the nourishing sweets of earth
To give us bliss, that we may drink the sparkling wine of Los
And let us laugh at war,
Despising toil and care,
Because the days and nights of joy in lucky hours renew.
Arise O Orc from thy deep den,
First born of Enitharmon rise!
And we will crown thy head with garlands of the ruddy vine:
For now thou art bound:
And I may see thee in the hour of bliss, my eldest born.
The horrent Demon rose surrounded with red stars of fire
Whirling about in furious circles round the immortal fiend.
Then Enitharmon down descended into his red light,
And thus her voice rose to her children, the distant heavens reply

PLATE 5

Now comes the night of Enitharmons joy,
Who shall I call? Who shall I send!
That Woman, lovely Woman! may have dominion?
Arise O Rintrah thee I call! & Palamabron thee!
Go: tell the human race that Womans love is Sin:
That an Eternal life awaits the worms of sixty winters
In an allegorical abode where existence hath never came:
Forbid all Joy, & from her childhood shall the little female
Spread nets in every secret path.
My weary eyelids draw towards the evening, my bliss is yet but
 new. Arise

PLATE 8

Arise O Rintrah eldest born, second to none but Orc:
O lion Rintrah raise thy fury from thy forests black:
Bring Palamabron horned priest, skipping upon the mountains:
And silent Elynittria the silver bowed queen:
Rintrah where hast thou hid thy bride:
Weeps she in desart shades?

Alas my Rintrah! bring the lovely jealous Ocalythron.
Arise, my son: bring all thy brethren O thou king of fire.
Prince of the sun I see thee with thy innumerable race:
Thick as the summer stars:
But each ramping his golden mane shakes.
And thine eyes rejoice because of strength O Rintrah furious
 king.

PLATE 9(a)

Enitharmon slept,
Eighteen hundred years: Man was a Dream!
The night of Nature and their harps unstrung:
She slept in middle of her nightly song
Eighteen hundred years, a female dream!
Shadows of men in fleeting bands upon the winds
Divide the heavens of Europe
Till Albions Angel smitten with his own plagues fled with his
 bands
The cloud bears hard on Albions shore:
Fill'd with immortal demons of futurity:
In council gather the smitten Angels of Albion
The cloud bears hard upon the council house: down rushing
On the heads of Albions Angels.
One hour they lay buried beneath the ruins of that hall;
But as the stars rise from the salt lake they arise in pain,
In troubled mists o'erclouded by the terrors of strugling times.

PLATE 9(b)

In thoughts perturb'd they rose from the bright ruins silent fol-
 lowing
The fiery King, who sought his ancient temple serpent-form'd
That stretches out its shady length along the Island white.
Round him roll'd his clouds of war; silent the Angel went,
Along the infinite shores of Thames to golden Verulam.
There stand the venerable porches that high-towering rear
Their oak-surrounded pillars, form'd of massy stones, uncut
With tool, stones precious; such eternal in the heavens,
Of colours twelve, few known on earth, give light in the opake,
Plac'd in the order of the stars, when the five senses whelmd
In deluge o'er the earth-born man; then turn'd the fluxile eyes
Into two stationary orbs, concentrating all things,
The ever-varying spiral ascents to the heavens of heavens
Were bended downward; and the nostrils golden gates shut
Turn'd outward, barr'd and petrify'd against the infinite.
Thought chang'd the infinite to a serpent; that which pitieth;
To a devouring flame; and man fled from its face and hid
In forests of night; then all the eternal forests were divided
Into earths rolling in circles of space, that like an ocean rush'd
And overwhelmed all except this finite wall of flesh.
Then was the serpent temple form'd, image of infinite
Shut up in finite revolutions, and man became an Angel;
Heaven a mighty circle turning; God a tyrant crown'd.
Now arriv'd the ancient Guardian at the southern porch,
That planted thick with trees of blackest leaf, & in a vale
Obscure, inclos'd the Stone of Night; oblique it stood, o'erhung
With purple flowers and berries red; image of that sweet south,
Once open to the heavens, and elevated on the human neck,
Now overgrown with hair and coverd with a stony roof.
Downward 'tis sunk beneath th' attractive north, that round the
 feet
A raging whirlpool draws the dizzy enquirer to his grave.

PLATE 10

Albions Angel rose upon the Stone of Night.
He saw Urizen on the Atlantic;
And his brazen Book,
That Kings & Priests had copied on Earth
Expanded from North to South.

PLATE 12

And the clouds & fires pale rolld round in the night of Enithar-
 mon
Round Albions cliffs & Londons walls: still Enitharmon slept.
Rolling volumes of grey mist involve Churches, Palaces, Towers;
For Urizen unclasp'd his Book: feeding his soul with pity
The youth of England hid in gloom curse the pain'd heavens:
 compell'd
Into the deadly night to see the form of Albions Angel
Their parents brought them forth & aged ignorance preaches
 canting.
On a vast rock, percievd by those senses that are clos'd from
 thought:
Bleak, dark, abrupt, it stands & overshadows London city
They saw his boney feet on the rock, the flesh consum'd in flames:
They saw the Serpent temple lifted above, shadowing the Island
 white:
They heard the voice of Albions Angel howling in flames of Orc,
Seeking the trump of the last doom
Above the rest the howl was heard from Westminster louder &
 louder;
The Guardian of the secret codes forsook his ancient mansion
Driven out by the flames of Orc; his furr'd robes & false locks
Adhered and grew one with his flesh, and nerves & veins shot
 thro' them
With dismal torment sick hanging upon the wind: he fled
Groveling along Great George Street thro' the Park gate: all the
 soldiers
Fled from his sight: he drag'd his torments to the wilderness.
Thus was the howl thro' Europe!
For Orc rejoic'd to hear the howling shadows
But Palamabron shot his lightnings trenching down his wide back
And Rintrah hung with all his legions in the nether deep.
Enitharmon laugh'd in her sleep to see (O womans triumph!)
Every house a den, every man bound; the shadows are filld
With spectres, and the windows wove over with curses of iron:
Over the doors Thou shalt not: & over the chimneys Fear is writ-
 ten:
With bands of iron round their necks fasten'd into the walls
The citizens: in leaden gyves the inhabitants of suburbs
Walk heavy: soft and bent are the bones of villagers.
Between the clouds of Urizen the flames of Orc roll heavy
Around the limbs of Albions Guardian, his flesh consuming.
Howlings & hissings, shrieks & groans, & voices of despair
Arise around him in the cloudy Heavens of Albion. Furious

PLATE 13

The red limb'd Angel siez'd in horror and torment
The Trump of the last doom: but he could not blow the iron
 tube!
Thrice he assay'd presumptuous to awake the dead to Judgment.
A mighty Spirit leap'd from the land of Albion,
Nam'd Newton: he siez'd the trump, & blow'd the enormous
 blast!

Yellow as leaves of Autumn the myriads of Angelic hosts
Fell thro' the wintry skies seeking their graves:
Rattling their hollow bones in howling and lamentation.
Then Enitharmon woke nor knew that she had slept
And eighteen hundred years were fled
As if they had not been.
She call'd her sons & daughters
To the sports of night,
Within her crystal house:
And thus her song proceeds.
Arise Ethinthus! tho' the earth-worm call
Let him call in vain:
Till the night of holy shadows
And human solitude is past!

PLATE 14

Ethinthus queen of waters how thou shinest in the sky:
My daughter how do I rejoice! for thy children flock around
Like the gay fishes on the wave, when the cold moon drinks the
 dew.
Ethinthus! thou art sweet as comforts to my fainting soul:
For now thy waters warble round the feet of Enitharmon.
Manathu-Vorcyon! I behold thee flaming in my halls,
Light of thy mothers soul! I see thy lovely eagles round:
Thy golden wings are my delight, & thy flames of soft delusion.
Where is my lureing bird of Eden! Leutha silent love!
Leutha, the many coloured bow delights upon thy wings:
Soft soul of flowers Leutha!
Sweet smiling pestilence! I see thy blushing light:
Thy daughters many changing,
Revolve like sweet perfumes ascending O Leutha silken queen!
Where is the youthful Antamon, prince of the pearly dew.
O Antamon, why wilt thou leave thy mother Enitharmon?
Alone I see thee crystal form,

Floting upon the bosomd air
With lineaments of gratified desire.
My Antamon the seven churches of Leutha seek thy love.
I hear the soft Oothoon in Enitharmon's tents:
Why wilt thou give up womans secrecy my melancholy child?
Between two moments bliss is ripe:
O Theotormon robb'd of joy, I see thy salt tears flow
Down the steps of my crystal house.
Sotha & Thiralatha, secret dwellers of dreamful caves,
Arise and please the horrent fiend with your melodious songs.
Still all your thunders golden hoofd, & bind your horses black.
Orc! smile upon my children!
Smile son of my afflictions.
Arise O Orc and give our mountains joy of thy red light.
She ceas'd, for All were forth at sport beneath the solemn moon
Waking the stars of Urizen with their immortal songs,
That nature felt thro' all her pores the enormous revelry
Till morning ope'd the eastern gate.
Then every one fled to his station, & Enitharmon wept.
But terrible Orc, when he beheld the morning in the east,

PLATE 15

Shot from the heights of Enitharmon,
And in the vineyards of red France appear'd the light of his fury.
The sun glow'd fiery red:
The furious terrors flew around
On golden chariots raging, with red wheels dropping with blood:
The Lions lash their wrathful tails!
The Tigers couch upon the prey & suck the ruddy tide:
And Enitharmon groans & cries in anguish and dismay.
Then Los arose his head he reard in snaky thunders clad:
And with a cry that shook all nature to the utmost pole,
Call'd all his sons to the strife of blood.

FINIS